IMAGES
of America

FILIPINOS IN THE
WILLAMETTE VALLEY

ON THE COVER: Filipino musicians here are at the Christmas Party of St. Vincent's Hospital in 1949. On the left, 13-year-old Glenn Tadina holds a saxophone, his favorite musical instrument. Still playing in 2010, he has belonged to his own big band since high school. (FANHS-OR.)

IMAGES
of America

FILIPINOS IN THE
WILLAMETTE VALLEY

Tyrone Lim and Dolly Pangan-Specht
Filipino American National Historical Society
Oregon Chapter

ARCADIA
PUBLISHING

Published by Arcadia Publishing
Charleston SC, Chicago IL, Portsmouth NH, San Francisco CA

Printed in the United States of America

Library of Congress Control Number: 2010922848

For all general information contact Arcadia Publishing at:
Telephone 843-853-2070
Fax 843-853-0044
E-mail sales@arcadiapublishing.com
For customer service and orders:
Toll-Free 1-888-313-2665

Visit us on the Internet at www.arcadiapublishing.com

*Mabuhay to all Filipinos who have made the Willamette Valley their
home! The first picture (below, left) is Tyrone and his wife, Fonjie,
who were married on February 14, 1979. Mike Specht and Dolly
Pangan married each other for the second time on February 15, 1986.*

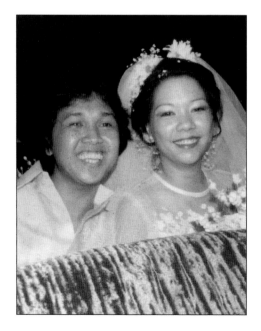

CONTENTS

FOREWORD

In January 2008, the members of FANHS-OR held their chapter meeting at the residence of Dolly Pangan-Specht, then the secretary and now the elected president for 2010. Dolly presented the series of *Filipinos in . . .* books by Arcadia Publishing, suggesting that our chapter should also publish our own *Filipinos in Oregon*. She further suggested that some pictures in the book *Filipino Americans: Pioneers to the Present* authored by myself, with Tyrone Lim as coauthor, may be used. I gave my consent as long as FANHS-OR is included and properly credited.

With the unanimous approval of the chapter membership, Dolly and Tyrone were then sent to task. Dolly was given the responsibility to take charge and to assure us that a book will be published. I recommended Tyrone Lim to be the lead author, because of his writing experiences as a former reporter for the National Food Authority in the Philippines and as past managing editor of the *Asian Reporter* in Portland.

This book is now entitled *Filipinos in the Willamette Valley,* emphasizing the importance of the valley in the development of Filipino communities and organizations dedicated to pursuing traditional expressions of culture, which are absorbed into the American mainstream.

Two years after that first mention, another good project of the FANHS-OR has been realized. The perseverance and patience of all involved, especially Tyrone and Dolly, are key words to be remembered. Perseverance is the father and Patience the mother of this successful offspring.

—Concordia R. Borja-Mamaril, Ph.D.

ACKNOWLEDGMENTS

Our heartfelt gratitude goes out to all those who made this book possible.

Thank you, FANHS-OR for the opportunity to present the Filipino American story in Oregon straight from its various collections by way of members' photograph albums, backroom files, and basement boxed collections. Thank you to the eminent FANHS-OR couple—Simeon Dacanay Mamaril, president for many years, and Concordia Borja-Mamaril, historian, author, and FANHS National Trustee—for everything they do for our chapter. Thank you, Ferdie and Adela Sacdalan for safekeeping the old photographs in our chapter. Thank you, Tony Cassera and Barbara Affleck for sharing your extensive photograph collections. Thank you, Lourdes and Julia Markley, Eric Tadeo, Ruth and Willie Olandria for your suggestions. Special thank you to Dorothy Cordova for your wisdom and moral support.

Thank you to all the Filipino American organizations that provided us information and photographs as well as individual members who generously shared their personal albums. Their names are mentioned in respective photograph courtesy credits.

Thank you, Arcadia Publishing for including us in this series that showcases our heritage and culture throughout the United States. We appreciate our editors Sarah Higginbotham and Devon Weston, who guided us through the process marvelously.

Last, but certainly not least, we would like to thank our dear friends and family for their unfailing love and support.

From Tyrone, to my wife, Fonjie, and our three lovely daughters Ricci, Punky, and Fides.

From Dolly, to my great-grandfather, Epifanio de los Santos, the foremost Filipino historian, for passing on the value and passion for my Filipino heritage, and to my family for allowing me the time and space to see this through.

Abbreviation Key to Filipino American Organizations in Photograph Credits:

ACNU	Aguman Capampangan Northwest USA
CSO	Cebuano Speaking Organization of Oregon and Washington
DCFAA	Douglas County Filipino American Association
FAACCV	Filipino American Association of Clark County and Vicinity
FAAPV	Filipino American Association of Portland and Vicinity
FAFC	Filipino American Friendship Club
FANHS-OR	Filipino American National Historical Society Oregon Chapter
GSFAA	Greater Salem Filipino American Association
PAA	Philippine American Association of Eugene and Springfield
WVFA	Willamette Valley Filipino Association

INTRODUCTION

The Willamette Valley is a broad stretch of fertile agricultural land in northwestern Oregon, forming the basin of the Willamette River, bounded by the Oregon Coast Range on the west and the Cascades on the east. It begins from the Calapooya Mountains near Eugene and runs 200 miles north up to its confluence with the Columbia River in Portland. The surrounding valley, one of the most fertile agricultural regions in North America, was the destination for many westward settlers along the Oregon Trail. Today the Willamette Valley is home to 70 percent of Oregon's population.

For the purposes of this book, the Willamette Valley we depict here includes the surrounding foothills, river valleys, and neighboring communities up to and including Portland and Vancouver, southwest Washington, which is just across the mighty Columbia River from Portland.

The westward expansion of the United States in the 1800s brought peoples from different nations (notably from Asia) to the shores of America. Filipinos were among them. Having sailed the vast Pacific Ocean, they landed in the populated regions of Hawaii and the West Coast, in what is considered the first wave of Filipino immigration to the United States. It crested during the years following the end of the Spanish-American War in 1898, when the Philippine islands were sold by Spain to the United States for $20 million. Handed over from one colonizer to another, Filipinos instantly became American nationals and allowed to travel to America without passports. Thousands of Filipinos sailed to America between 1898 and July 4, 1946, the year the United States ended its commonwealth in the Philippines, granting its independence.

The first Filipinos to arrive in America came courtesy of the Americans themselves. The United States had just repelled the brave Filipino nationalists during the Philippine-American War (1899–1902), but to the Filipinos, it was their first defense of their young country, having just declared their independence from Spain in 1896. America's territorial government, in its mission of fulfilling the "white man's burden" to his "brown brothers," started sponsoring Filipino students to study in the United States. Beginning in 1903, several hundred Filipinos arrived to achieve their educational opportunities. Oregon's two biggest centers of education in the Willamette Valley, predecessors of today's University of Oregon in Eugene and Oregon State University in Corvallis, thus became home to students of the emerging nation. They were mostly adventurous males from well-connected families. Most of them returned home at the end of their course.

At the same time, Filipinos also worked in agriculture on the orchards of the Willamette Valley competing for their labor against fruit and vegetable farming operations in California and Washington. They also worked in the canneries of Alaska and pineapple and sugar plantations in Hawaii.

Between the lowly agricultural workforce and the elite *pensionados* (government scholars), Filipino immigration continued to surge into the latter waves of migration. Service workers like houseboys, waiters, cooks, bartenders, and domestics began arriving in the 1920s and 1930s.

Photographs from the FANHS-OR show well-dressed men attending parties. "You can never tell these men were houseboys and cooks by the way they dressed during these gatherings," remarked chapter archivist Fernando Sacdalan.

The end of World War II saw the coming of the war brides. Oregon had its share of them, marrying Filipino as well as American soldiers who were stationed in the islands during the war. The Filipino soldiers were themselves either earlier immigrants or second-generation Filipino Americans born in the United States. The years after the war also saw a spike among Filipinos enlisting in the U.S. military, mostly with the navy.

What FANHS considers the current Fourth Wave of Filipino migration started with the passage of new immigration and naturalization laws in 1965. This time, a new class of immigrants came. Educated and highly desired professionals, especially doctors, nurses, and engineers, created a boom of immigrants to America on the one hand, and a problematic "brain drain" for the country of origin on the other. One country's loss is another's gain, and America benefited in this equation.

More than a geographic distribution of the Filipino population in Willamette Valley, this book also portrays the growth and development of Filipino communities in each of the main cities in the valley. It started in Portland in 1959, the seat of the oldest Filipino American Association in Oregon. It is the first Filipino American group in Oregon with its own building. The struggles and hardships that the group suffered to acquire its property is a story in itself worth telling in another publication.

The growth in numbers of Filipino community members (not to mention the distance to Portland) necessitated those residing in outlying areas to form their own groups. The earlier ones tended to be primarily social organizations, filling the need for camaraderie among compatriots. From the 1980s on, new focus-oriented groups reflected the maturation process for Filipinos' interests in local community, cultural traditions, the arts, professions, and careers, among others.

Thus, the first two chapters trace Filipinos' arrival in Eugene, Corvallis, Salem, Portland, and Vancouver and their eventual dispersal into the neighboring communities. The succeeding chapters depict their natural and cultural tendency for social interaction, especially with fellow Filipinos, the subsequent formation of goal-specific Filipino American organizations, their activities over the years, featuring some of their more prominent members.

Current Filipino immigrants to the United States in general come from all education and income levels, and the same can be said of those making Willamette Valley their new home.

Most of the research for this book has been made easy by the voluminous material available from FANHS-OR Chapter's handling of the exhibit *Filipino Americans: Pioneers to the Present*, held at the Oregon History Center in Portland from June 1997 to February 1998, and the subsequent book of the same title, published in 2000. Much of the credit belongs to Dr. Concordia Borja-Mamaril, who served as cochair of the exhibit, as well as authored the book.

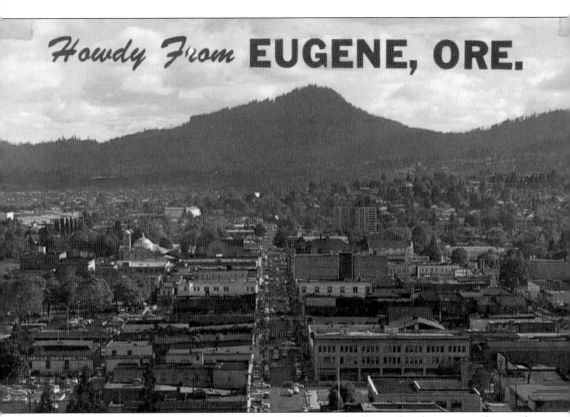

Howdy From **EUGENE, ORE.**

This postcard is from Simeon D. Mamaril's 1963 photograph album when he was a student at the University of Oregon. It shows the city of Eugene in 1963 and the mountains to the south of it. There the Willamette River begins and winds its way north to Portland.

One

HEART OF THE VALLEY

In the heart of the Willamette Valley sit the three cities that Filipinos called home since about a century ago. From the state capital (Salem), through the valley's core (Corvallis), and the gem of the south (Eugene), early Filipino migrants congregated for various purposes. The flat terrain invited widespread agriculture, and many Filipino workers already in Hawaii came to the West Coast to find better working and living conditions. Since the valley was not a direct port of call from overseas (those transoceanic vessels landed in San Francisco, Seattle, or Vancouver, British Columbia), Filipinos living there more likely belonged to a farm crew being shuttled from one camp to another. They were shuttled up from California in transit to Washington, Idaho, and Montana, and ended up working in cherry orchards and hops farms in Salem and surrounding towns, among others. At the start of the 20th century, the town of Independence, mid-valley on the west bank of the Willamette, carried Oregon to rank number one in the nation in hops (an ingredient in beer making) production from 1905 to 1915 and again from 1922 to 1943.

At about the same period, Filipino students started populating the campuses of Oregon Agricultural College in Corvallis and the Oregon College of Literature, Science, the Arts, and Humanities (now University of Oregon) in Eugene, among other schools. The earliest recorded Filipino students came to Eugene in 1906, and to Corvallis in 1911, according to research by FANHS-OR members Willie and Ruth Olandria. Not all early arrivals came for college education. The later 1920s *Eugenean*, the memory book of Eugene High School, had several students from the Philippines.

Not many of the Filipinos listed in the yearbooks of those early years had any descendants or relatives still living in Oregon, much less in the Willamette Valley, owing most likely to, first, job and family circumstances where they could be found, or second, the footloose Filipino nature of wishing to experience living in different places, or both.

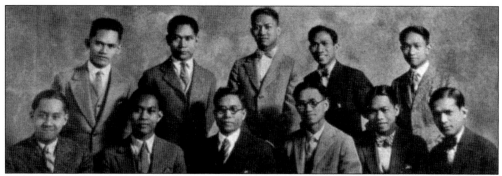

The first Filipino to study at the Oregon College of Literature, Science, the Arts, and Engineering in Eugene in 1906–1907 was Augusto Hidalgo of Manila. In 1922, the Filipino students organized the Varsity Philippinensis for purposes of fostering friendship and fellowship, of creating better understanding between Filipinos and other students, and for educating the American public on Philippine issues. The photograph shows members of the 1926 varsity class. (Courtesy FANHS-OR and University of Oregon.)

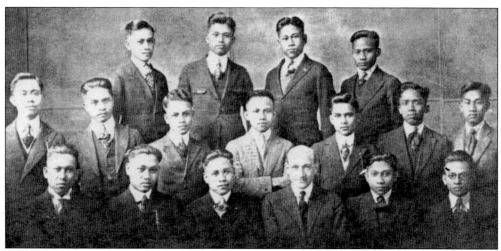

The 1921 *Beaver*, the yearbook of the Oregon Agricultural College in Corvallis, listed Marcos Alicante Jr. as the only Filipino in the graduating class of 1921 and the only senior belonging to the Filipino Club (first row, third from left). The club was formed in 1918 with the purpose of bringing Filipino students together and helping students newly arrived from the Philippines to become adjusted to college life. (Courtesy FANHS-OR and Oregon State University.)

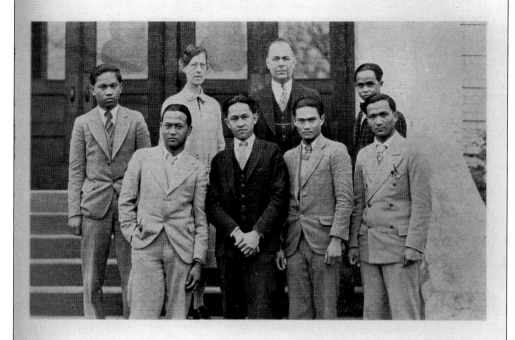

THE FILIPINO CLUB

FIRST SEMESTER	OFFICERS	SECOND SEMESTER
Alfonso Domingo	*President*	Alfonso Domingo
Alfonso Sarmiento	*Vice-President*	Arturo Reniedo
Pastor Buen	*Secretary-Treasurer*	Eugenio Gaona

MEMBERS

Alfonso Domingo, Arturo Reniedo, Eugenio Gaona, Numeriano Valin, Arcade Cabang, Francisco Degala.

This page from the 1929 *Eugenian* shows smartly dressed high school gentlemen of the Filipino Club. There were a few Filipinos from the Philippines who were enrolled at Eugene High School, as evidenced in the *Eugenian* of years 1926 through 1929. As told earlier in the chapter introduction, they were all male. (Courtesy Anselmo Villanueva, Ph.D.)

Frank Ebbesen arrived in the Philippines in 1917 as a "Thomasite," a name given to one of the many American teachers who went to the Philippines, coined after the ship USS *Thomas* that brought the first and biggest batch in August 1901. He was assigned to Ilocos Norte province, where he met and married Isabel Llantada. After his teaching service, the family moved to Manila, where he became a businessman. During World War II, Frank was a civilian prisoner of war interned at the University of Santo Tomas. He returned to Portland in June 1945 with his wife and seven children, one of whom is Florence Gonzales, shown below in this photograph. (Both, courtesy FANHS-OR.)

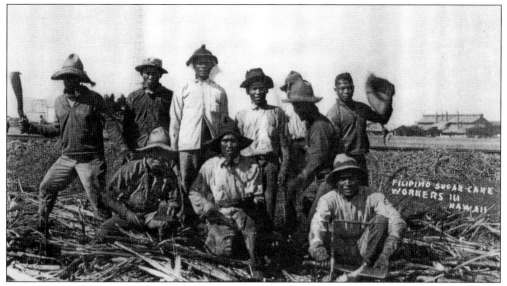

When the United States annexed Hawaii as a territory in 1907, Japanese immigration to the islands stopped. Pineapple and sugarcane plantations needed workers, and they began to look to the Philippines, offering three-year contracts. Many of them returned home telling stories of their experience. This enticed other Filipinos, through word of mouth, to try their luck in the "Land of Plenty." (Courtesy Ronald Takaki, *In The Heart Of Filipino America*.)

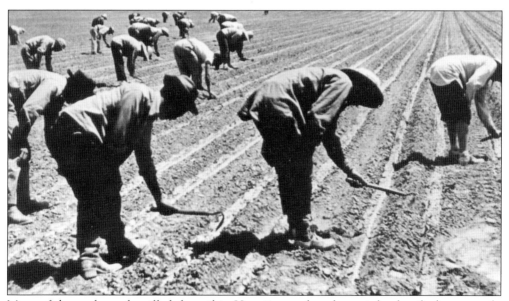

Many of the workers who tilled the soil in Hawaii moved to the mainland to find more work. Labor contractors negotiated with the growers, shuttling crews to vegetable farms in California. Some went to Montana and Colorado to harvest sugar beets, Idaho to dig potatoes, Washington to pick apples, and Oregon to gather flowers of hops, an ingredient in beer production. (Courtesy Fred Cordova, *Filipinos: Forgotten Asian Americans*.)

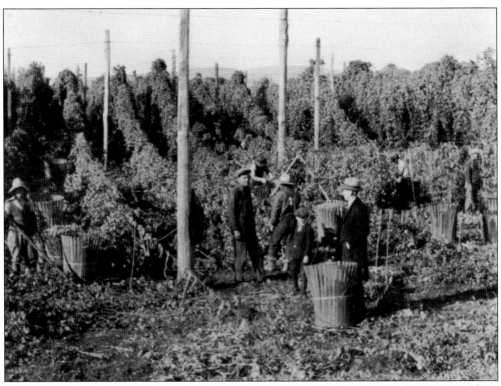

Hops growers hired as many as 5,000 transient workers in 1923 in the Salem area alone. Most of these workers returned year after year to the same ranch. This photograph shows the height of the hops-picking season in Independence, Oregon, in 1930. (Courtesy Marion County Historical Society.)

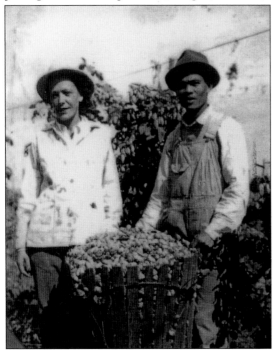

Zona and Peter Nebrija pick hops in 1930 in Brown Island, Salem. By 1939, about one-half of all American hops were grown in Oregon. A downy mildew infestation dropped production numbers in 1953 considerably, but Washington and Idaho picked up the slack. (Courtesy Marion County Historical Society.)

Macario Corpuz was 17 years old when he arrived in Portland in 1919. He saved the money he earned at the fish canneries in Alaska and hops fields in Oregon to go back to school. He graduated in 1926 from Grant High School in Portland, and in 1941 received his degree in political science from Willamette University in Salem. He is also shown below in a book cover photograph with friends and relatives. Seated are, from left to right, Andres Pulanco, Lauriano Pulanco, and Domingo Hidalgo; (standing) Victor Lomboy, Antonio Abuan, Mariano Abuan, and Macario Corpuz. This photograph was the cover image for the 2000 book *Filipino Americans: Pioneers to the Present*, published by FANHS-OR. (Both, courtesy FANHS-OR.)

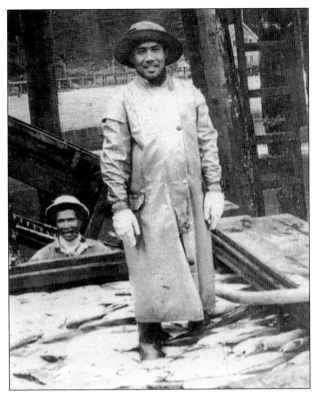

FILIPINO AMERICANS
PIONEERS TO THE PRESENT

Concordia R. Borja - Mamaril
and
Tyrone Lim

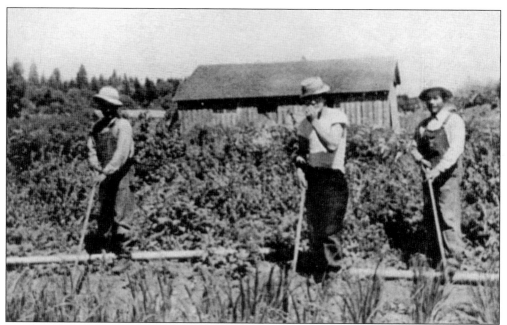

It was not all hops picking for Salem area farm workers. In the 1930s, Vicente Castulo (center) hoed onion fields with friends. Gloria Delfin, another farm worker's daughter, said, "We had to move to where my father could find work and sometimes he would leave us for long periods to work the fish canneries of Alaska, in hop yards or pick apples and pears in Hood River." (Courtesy FANHS-OR and Castulo family.)

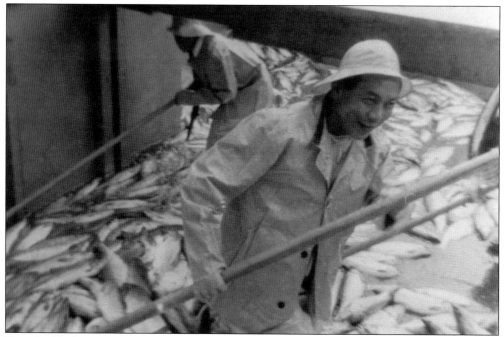

Terry Noble from Aringay, La Union province, hauled and cleaned salmon in the early 1930s in Alaska. He did a variety of manual jobs to support himself and his family. (Courtesy FANHS-OR and Ray Noble.)

Terry Noble's son Raymond, then 17, also worked in the canneries. Here he poses (right) with two coworkers and some big fish at Waterfall Fish Cannery in 1954. Cannery work ran for one season, usually in the summer, working in offshore boats for months without seeing land. Many Filipinos loved this work arrangement, as they worked for months in a row, went home with pay intact and unspent, then relaxed and enjoyed life with family. (Courtesy FANHS-OR and Ray Noble.)

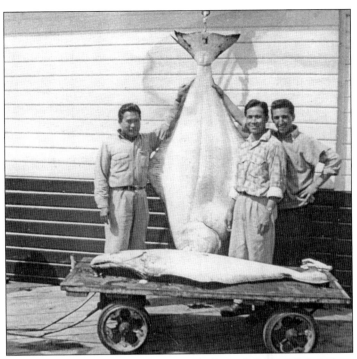

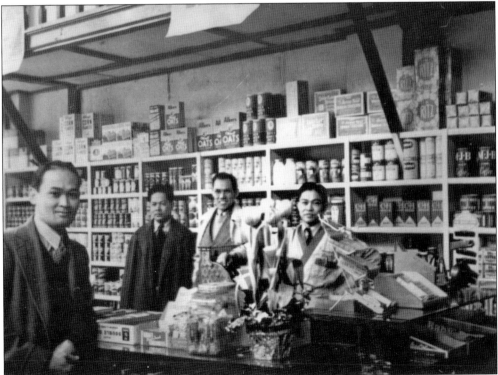

Graciano "Rocky" Hortaleza (left) poses with friends at a grocery store in Portland. He was an undergraduate of University of Oregon in 1930. His American friends could not pronounce his name correctly, but since it sounded like Rocky Marciano's, the nickname stuck. (Courtesy FANHS-OR.)

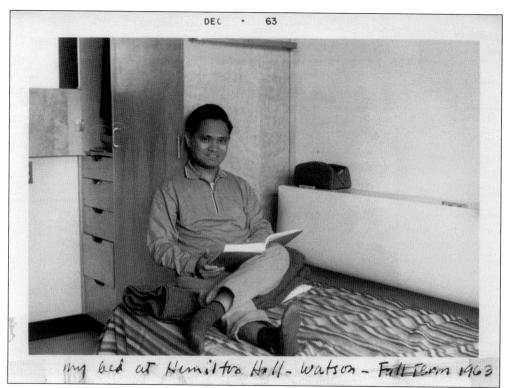

my bed at Hamilton Hall - Watson - Fall Term 1963

Simeon Mamaril was at his dorm room at the University of Oregon when he heard on the radio the assassination of President Kennedy. Mamaril was enrolled in the master of business administration economics program in 1963, on a one-year study leave from the Philippine National Bank. After the course, he trained at the International Department of the First National Bank of Oregon. (Courtesy Simeon D. Mamaril.)

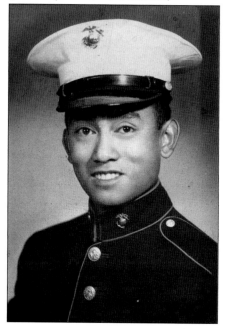

The first Filipino American casualty from Oregon in the Korean War of 1950–1951 was Manuel Mamaril Jr., born in Arlington in the 1930s. He was a third-year civil engineering student when he was drafted for military service. Wounded June 1951, he was promoted to corporal and awarded the Purple Heart. Soon after, he returned to the front and died in action on September 11, 1951. (Courtesy Simeon D. Mamaril.)

Two

BIG CITY

Whereas those working in agriculture had little education, Filipinos arriving in Portland were a mixed bag. Some were well-off and could afford passage to America, while others were indentured. The hardworking Pinoy (an endearing term for a male Filipino; Pinay for female) was diligent, ever hopeful of good to come out of adversity, and blessed with good behavior and religious faith, instilled in them by their parents. Many Filipinos became personal employees of Americans who could hire houseboys, maids, valets, chauffeurs, gardeners, cooks, and similar workers. During the Great Depression, any job was snatched up as an opportunity for advancement.

The decision to stay during the harsh economic times forced them to look for mates, preferably Filipina. But women were hard to come by, for in the 1930s the Filipino male-female ratio was 14 to 1. Filipino men had to socialize (sometimes illicitly) with women of other ethnicities, including Caucasians from Europe. The main deterrence of Filipino men consorting with white women were laws passed by 26 states, including California and Oregon. Antimiscegenation laws forced interracial couples to travel to "free" states to get married.

When World War II broke out in the Pacific, two Filipino regiments were deployed under the U.S. Armed Forces in the Far East. After the war, many of these soldiers would send for their war brides and settle in the Willamette Valley. They all came to America in the late 1940s up to the early 1950s under a non-quota classification by virtue of the War Bride Act of 1945.

Filipino communities developed out of necessity. As more and more Filipinos arrived, they organized themselves into groups. Wherever Filipinos were, it became a gathering place. Nevertheless, Filipinos seldom formed ethnic neighborhoods like Chinatown or Little Tokyo, purely because of their way of life—always moving around as migratory workers with no fixed homes.

Like other Asian ethnic races, Filipinos were barred from joining (or being seen in) white establishments. Thus, Filipino clubs and organizations ensured cultural security to the immigrants, especially during the years of their struggle for recognition against racial discrimination and prejudice in America.

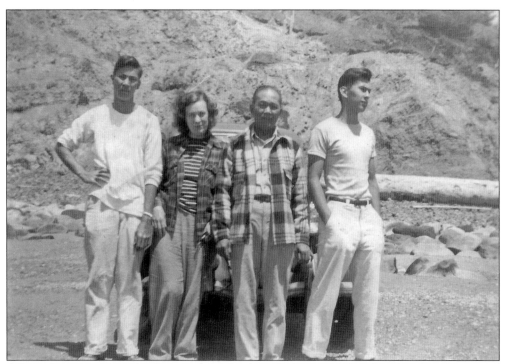

Adrian Guimary was a cabin boy in a boat that brought him in 1912 to Seattle, where he jumped ship. He worked odd jobs before he married Ellen Jean Lund in 1928 in Stevenson, Washington. Ellen's parents came to America in the 1880s from Sweden. This photograph shows Adrian and Ellen in 1952 with their two boys, Don (left) and Ray. (Courtesy Ray Guimary.)

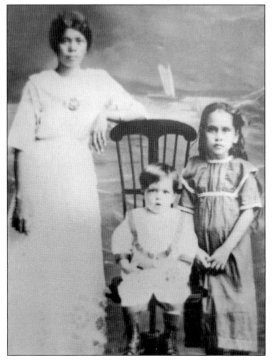

Jacinta Jones was the second Filipina wife of American soldier Albert Jones during the Philippine-American War in 1900. The photograph was taken before Jacinta, son Ernest, and stepdaughter Dominga came to Oregon in 1916. (Courtesy FANHS-OR and Gloria Delfin.)

Julian and Yolanda Galvez flank daughter Joanne on the Oregon coast in 1944. Julian left San Fernando, La Union province, in the late 1920s for the United States. He married Yolanda Carulli, of Italian descent, in 1934 in Vancouver, Washington. (Courtesy FANHS-OR.)

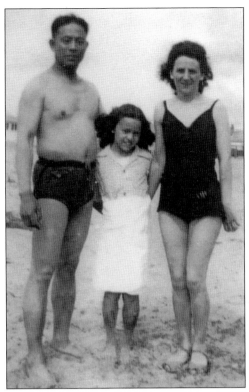

Maude Andrews of Portland married Paul Ancheta in 1935. Interracial unions were not allowed in Portland, so they had to go across the river to get married in Vancouver. California's antimiscegenation law was declared unconstitutional in 1948; other states, including Oregon, followed suit not long after. (Courtesy FANHS-OR and Ancheta family.)

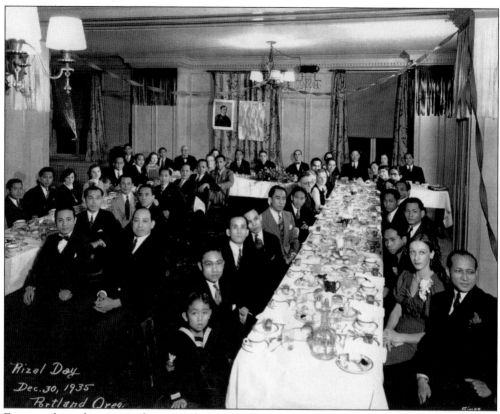

Rizal Day
Dec. 30, 1935
Portland Ore.

Far away from their native home, early Filipino Portlanders remembered to celebrate important Philippine holidays such as Rizal Day (the day of martyrdom of their national hero Jose Rizal, who was executed by the Spanish on December 30, 1896), above, and the establishment of the Philippine Commonwealth (below), the 10-year transition period (1935–1946) from being an American territory to a fully independent nation. Many of the participants in these celebrations were to become the pioneering leaders of the Filipino community in Portland and Oregon. (Both, courtesy FANHS-OR.)

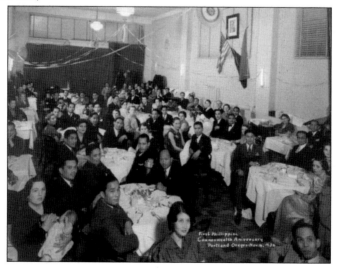

During the hostile environment of the 1930s and 1940s, members of fraternal lodges provided a sense of belonging. The Caballeros de Dimas Alang (pen name of national hero Dr. Jose Rizal), at its height, had 2,000 members with more than 100 lodges, including 10 women's lodges. (Courtesy FANHS-OR.)

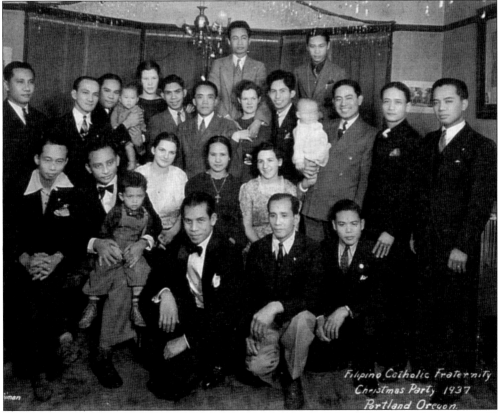

With the Philippines being of Catholic majority, it was natural that Filipinos in America would congregate under a church organization. The Filipino Catholic Fraternity was one such group in 1937, and Marcella Apilado (wearing cross necklace) was among its strongest members. (Courtesy FANHS-OR.)

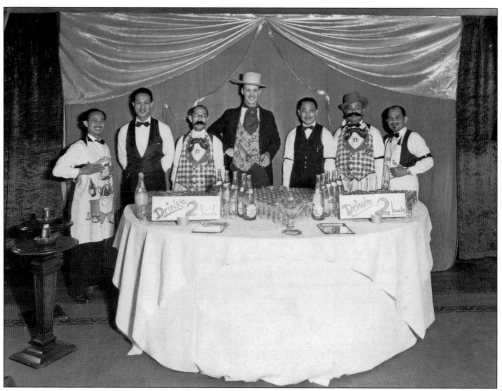

America's atmosphere during the postwar years was one of fun, merriment, and pleasure. Bartending became a popular job, and these photographs show just how much creativity and personal enjoyment was experienced. (Both, courtesy Simeon D. Mamaril and Mario Balangue.)

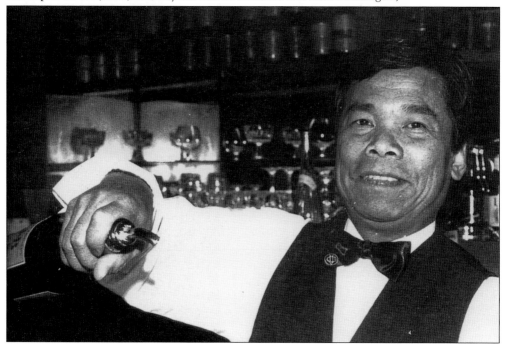

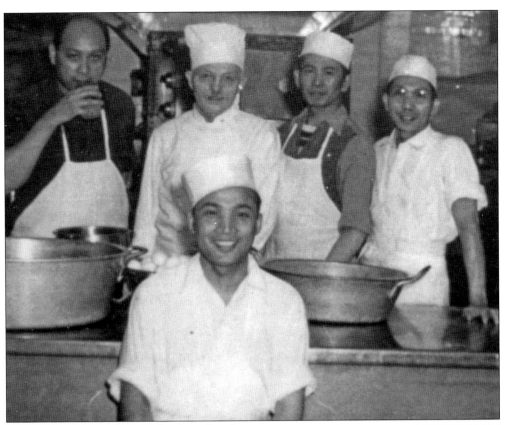

St. Vincent's Hospital in Portland employed a lot of Filipinos, which continues to this day. Filipino cooks (above) in 1948 included, clockwise from front: Kenny Evangelista, Max Munoz, Chef Simonelli, Johnny Soy, and Fermin Nieves. (Courtesy FANHS-OR.)

American establishments preferred to hire Filipino waiters, because they had a reputation for being courteous and prompt. At the University Club in downtown Portland, many Filipinos had been employed as service workers since 1924, including Macario Pimentel (left) and Pablo Dulay. Most coworkers usually came from the same hometown in the Philippines, and employers were happy to hire them, as they came recommended. (Courtesy FANHS-OR.)

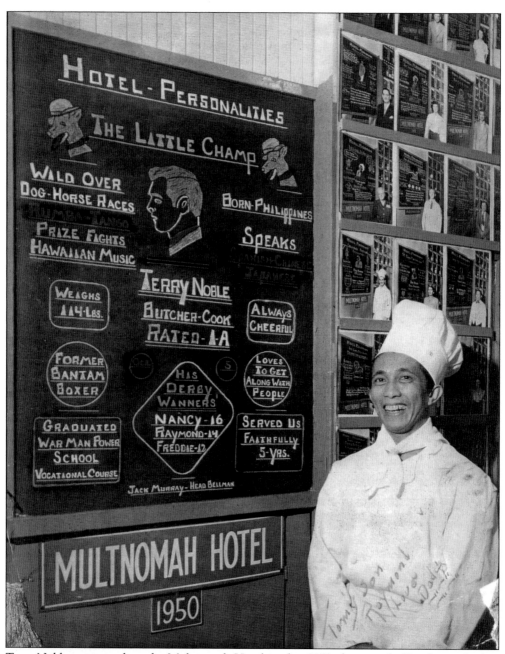

Terry Noble was a cook at the Multnomah Hotel in this 1950 photograph. He also worked in canneries in Alaska in his younger years. The majority of Filipinos are hardworking and not ashamed to do manual work. It is common to hear them say, "There is dignity in labor." Even Filipinos with college degrees, upon arrival in America, would accept a lesser job while seeking better job opportunities. (Courtesy FANHS-OR.)

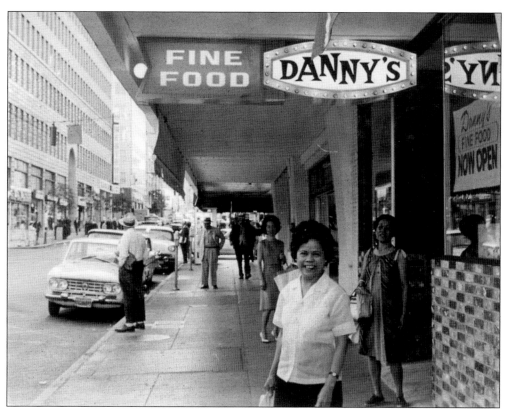

Danny's Restaurant was a refuge and informal employment agency for newly arrived Filipinos in the 1960s. Then located at Third Avenue and Yamhill Street in downtown Portland, it was owned and operated by Danny and Jojo Retuta from 1950 until 1974, one year after Danny died. Pictured at right, Tony Cassera (left) and Frank Gonzales worked in the kitchen at Danny's from the 1960s to the early 1970s. (Both, courtesy Anthony Cassera.)

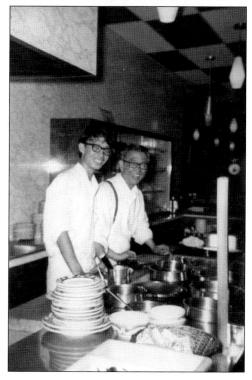

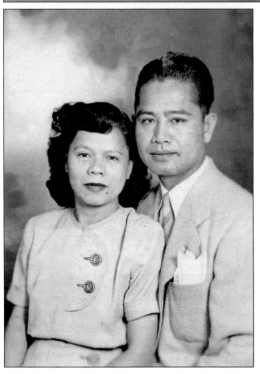

Danny's Fine Food restaurant was a gathering place for Filipino celebrities and glitterati. Jojo Retuta was a second cousin of past Philippine president Ferdinand Marcos. She was also a stage and film actress back home. In 1947, she married Danny Retuta (at left). When the couple moved to Portland in 1950 to open the restaurant, they hosted many events of the Filipino community. (Both, courtesy Anthony Cassera.)

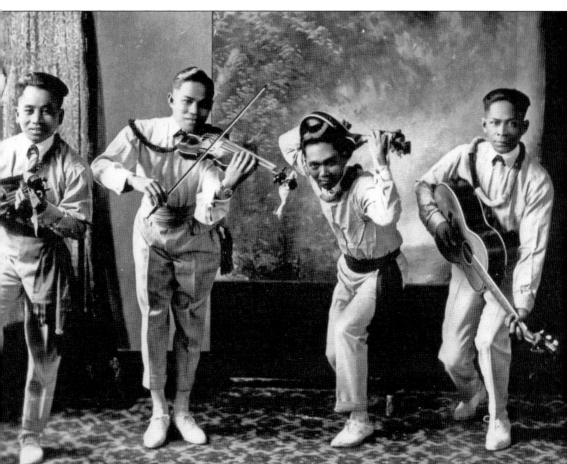

Adrian Guimary, second from right, strikes an entertaining pose with fellow musicians in this 1920s photograph. Adrian had a natural ear for music and was able to play the mandolin without formal training. He was also a vaudeville performer and later became a music teacher. (Courtesy Ray Guimary.)

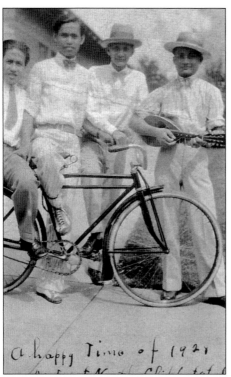

A happy Time of 1927

Many Filipinos love music, considering it a universal language that needs no interpretation, a talent that many enterprising Filipinos have made a living on. Paul Pimentel (middle left), his brother Macario (middle right) and two of their friends made their rounds in northeast Portland in 1928 serenading young women and their families. (Courtesy FANHS-OR and Felicidad Pimentel.)

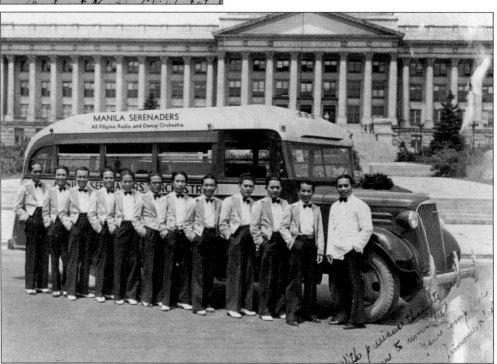

The Manila Serenaders, an all-Filipino radio and dance orchestra, stand against their tour bus in Utah in 1937. They charmed audiences from Oregon to Idaho and in the middle states from North Dakota to Texas. (Courtesy Fred Cordova, *Filipinos: Forgotten Asian Americans*.)

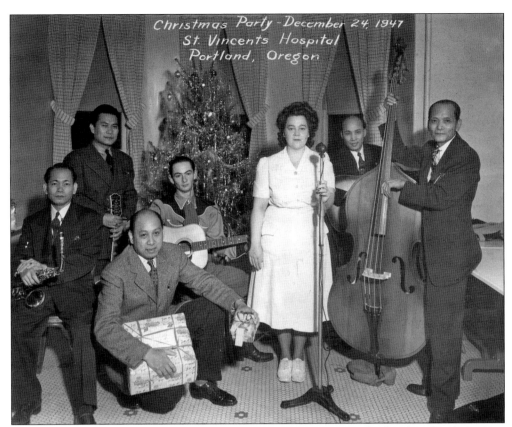

Filipino band members Silverio Rivera (with saxophone), Max Munoz (with gift package), Andrew Rivera (with cello), Kenny Evangelista (behind Andrew), unidentified guitarists, and singer performed at St. Vincent's Christmas program in 1947. (Courtesy FANHS-OR.)

Joseph Luarca, with ukulele, and friends engaged in impromptu jamming at a party in the 1930s. Many Filipinos in America love to incorporate music into their social gatherings, festivals, dances, and in their religious and other celebrations. (Courtesy FANHS-OR and Gloria Luarca Delfin.)

By the 1950s, Glenn Tadina was already an accomplished musician, having his own big band. He organized his first band in high school, and when he went to college at the University of Portland, his band members included his first wife, Vivian Hardy; sister Carolyn; and dad, Manuel. (Courtesy FANHS-OR and Glenn Tadina.)

Glenn Tadina, held by his mother, was born in 1936 in Salem to Manuel Tadina from San Fernando, La Union province, and Fleeda Dehut Satter, of Swedish-Belgian descent. Fleeda met Manuel while helping her father deliver milk to Filipino farm laborers. Manuel also worked as a machinist and carpenter, while Fleeda was a seamstress at Montgomery Ward. (Courtesy FANHS-OR and Glenn Tadina.)

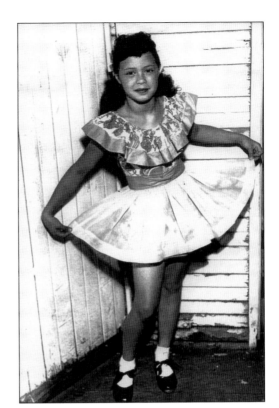

Carolyn Tadina was a tap dancer in the
eighth grade. She started tap dance lessons
at 8 years old. Her brother Glenn had been
playing the sax. After his performance
in this 1953 photograph, he was fondly
dubbed "Saxophobia" by friends. (Both,
courtesy FANHS-OR and Glenn Tadina.)

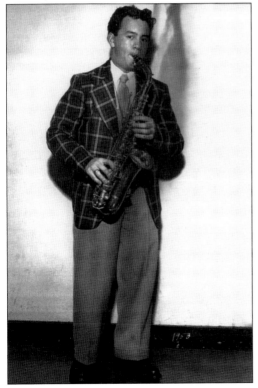

Johnny Soy landed in Seattle in 1929 from Dagupan, Philippines. He went directly to Portland and worked at St. Vincent Hospital as a janitor and cook before and after the war. He was deployed to the Philippines and was involved in mopping-up operations during World War II. (Courtesy FANHS-OR and Soy family.)

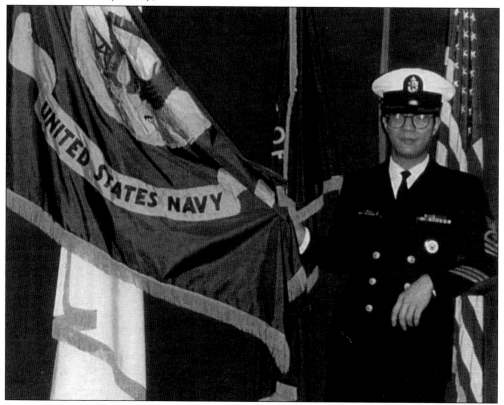

Jess Osilla, originally from Santa Barbara in Pangasinan province, joined the U.S. Navy in 1954 and retired after completing 20 years minimum service. Although retired, he volunteers in various civic and veterans clubs. (Courtesy FANHS-OR.)

Frank Cariño returned to his homeland to fight for the Americans during World War II. Near the military base where he was stationed was the house where Isabel Centeno lived. The two met at a town party and became friends, then married on June 6, 1945. When Frank returned to the United States, he petitioned for Isabel. (Courtesy FANHS-OR and Isabel Cariño.)

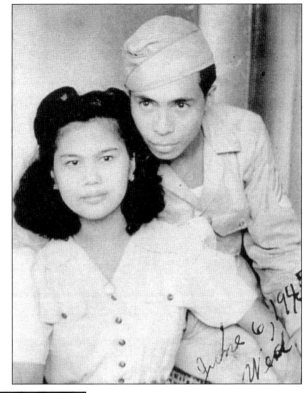

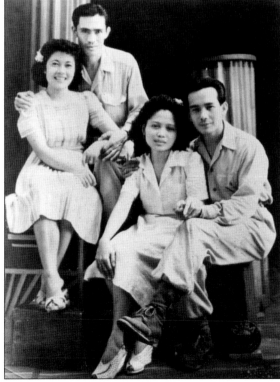

Pio and Pelagia Almero of Salem (couple at right) were among the many Filipino American servicemen and their war brides in 1945. They pose here with friends Mariano and Ying Angeles of Seattle. (Courtesy FANHS-OR.)

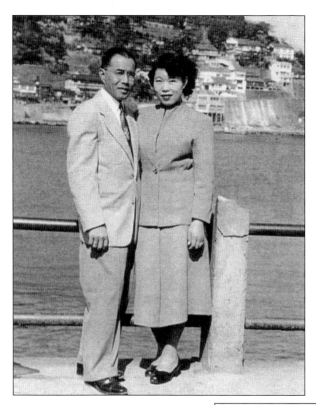

Macario Corpuz joined the Merchant Marine from 1950 through 1968, after years of toiling in farms and canneries around the West Coast. In Yokohama, Japan, he met Tsune Ito, whom he married in 1954. (Courtesy FANHS-OR.)

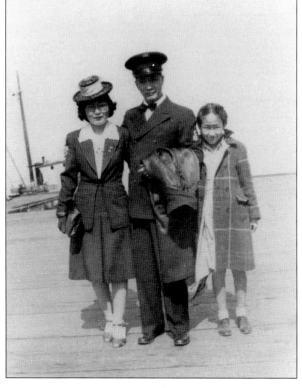

Marciano Pizarro poses with wife Hatsuko Ochida and daughter Irene in Astoria, Oregon, in 1945, when he was on furlough from the navy. He was chief steward on the ship patrolling the South Pacific during World War II. During his deployment, his wife and daughter were sent to a Japanese concentration camp. (Courtesy FANHS-OR.)

Portland war brides gather at a party around the 1950s. From left to right are Amada Jayme Soy, Norma Tomas Llanes, Ruperta Rodriguez de Leon, and Isabel Centeno Cariño. They all came to America in the late 1940s up to the early 1950s under a non-quota classification by virtue of the War Bride Act of 1945. (Courtesy FANHS-OR.)

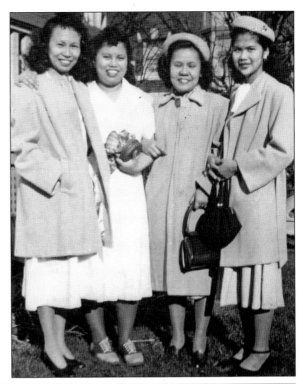

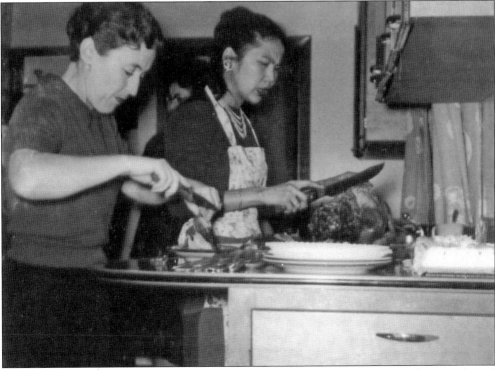

Isabel Cariño carves up a turkey to serve during Thanksgiving in the 1960s. Filipinos adopted American traditions as they continued to celebrate hometown customs. (Courtesy Isabel Cariño.)

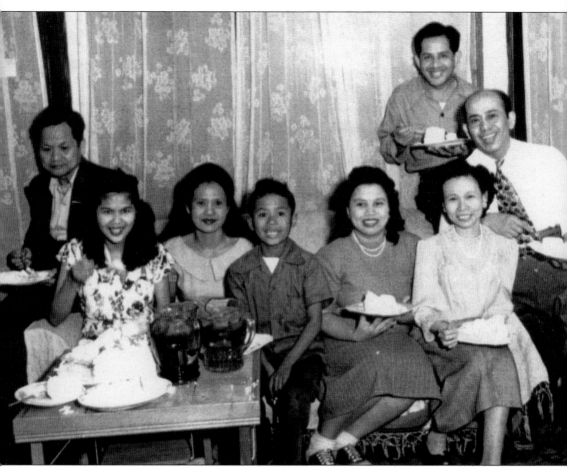

In the late 1940s and 1950s, the Filipino community, still mostly first-generation immigrants, started to have children born in the United States. Attending a birthday party for James Apilado in 1948 were (counterclockwise from left) Simplicio de Leon, Isabel Cariño, Marcella Apilado, James Apilado, Norma Llanes, Amada Soy, Johnny Soy, and Julian Llanes. (Courtesy FANHS-OR and Soy family.)

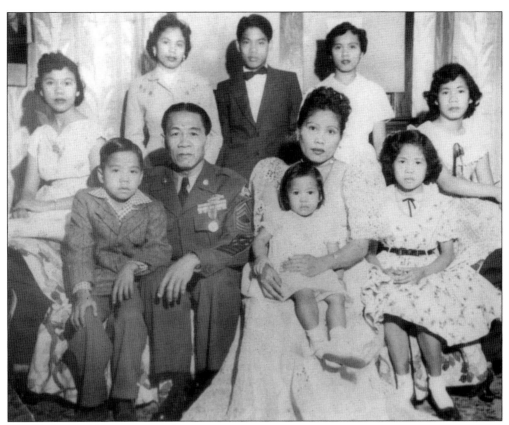

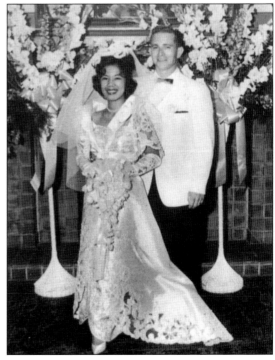

The Philippine Scouts was a military organization of the U.S. Army from 1901 through World War II, made up of Filipinos assigned to the U.S. Army's Philippine Department. Santiago Tabino joined the Philippine Scouts in 1926 and came to the United States in 1946 after the war. His family joined him in 1953. Above, from left to right are, (first row) Tobi, Santiago, Guadalupe, Lucy (on mom's lap), and Thelma; (second row) Julie, Edna, Santiago Jr, Minviluz, and Myrna. At right is Myrna Tabino, who married Bill Perkins on June 27, 1964, a year after she was named Miss Mindanao in the Filipino American Miss Philippines pageant. (Both, courtesy FANHS-OR and Myrna Perkins.)

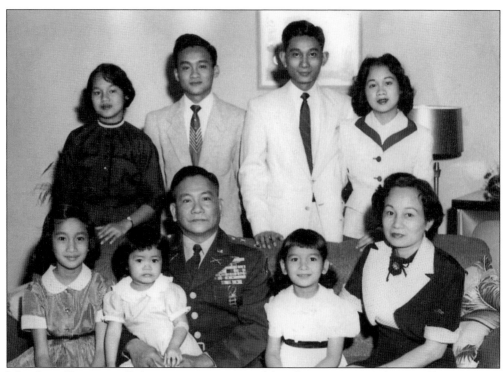

Librado and Justiniana Delumpa wrote memoirs of their lives in wartime: his guerilla experience as a Philippine Scout, later as a U.S. Army officer, and internment at Camp O'Donnell after surviving the harrowing Bataan Death March; hers a personal journal she kept since 1928. In this photograph taken six years after family's arrival in America in 1949 are, from left to right, (first row) Julie, Lori, Librado, Kathy, and Justiniana; (second row) Sally, William, Felix, and Maiah. Kathy, who is pictured below, is the only one who moved to Oregon, where she runs a wine shop-cum-art gallery in Gresham with husband Bill Allegri. (Both, courtesy Kathy Allegri)

Three

THE FIRST
FILIPINO AMERICAN

As mentioned earlier, Filipino communities grew out of the need to find and connect with one another. Several community and fraternal organizations began in the 1920s and 1930s among friends and colleagues at school and work, as well as those with a common hometown or cultural and historical heritage. The first registered group in Oregon is the nonprofit Filipino American Association of Portland and Vicinity (FAAPV or Filipino American Portland, for short). Incorporated in 1959, its purpose is to "protect the mutual interests of Filipino Americans, promote unity, understanding and cooperation among themselves, maintain and develop their cultural heritage, and foster friendly relations among themselves and with other races and nationalities."

The association was the brainchild of Vincent Perlas and friends. Perlas was a nursing graduate in Manila when he came to America in 1926. In Seattle, he worked as a dishwasher and persevered there until 1935, when he landed a job manning the first aid station of the U.S. Army Corps of Engineers constructing the Bonneville Dam. With the establishment of Filipino American Portland, he was elected its first president. A succession of prominent names in the Filipino community has served in various positions of leadership in the association.

In the beginning, meetings were held at members' homes, and with enough initial capital in 1971, the group secured a bank loan to purchase the property at 8917 Southeast Stark Street, previously belonging to the American Legion. The association held a series of fund-raising events through 1984, when a generous Domingo de Leon and his family donated $6,000 to pay off the loan balance. Today, 50 years later, the Filipino American Center, as the building is now called, still serves the community. Through the years, the association and the building have both been hosts and witnesses to countless stories and activities, as well as personal and public milestones of Filipinos in Oregon and the Willamette Valley.

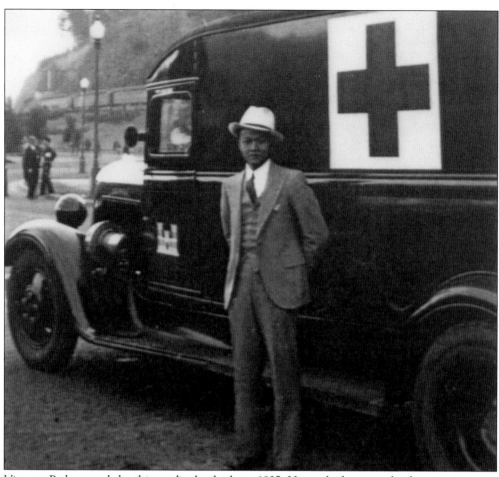

Vincent Perlas stands by this medical vehicle in 1935. He worked as a medical station nurse at the Bonneville Dam northeast of Portland. He wanted his young family, shown in the following photograph (wife Carolina and kids Gale, Richard, and Lina in 1945), to remember their Filipino roots and so banded with other Filipino families to establish the Filipino American Association of Portland and Vicinity. (Both, courtesy FANHS-OR.)

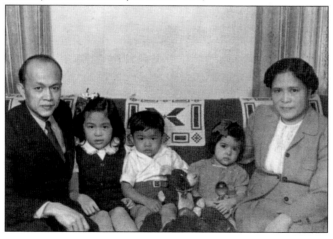

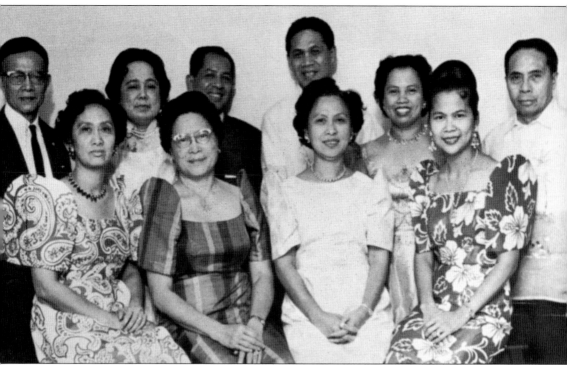

The founders of the Filipino American Association of Portland and Vicinity were the backbone of the organization participating in all the social, cultural, and civic activities in its calendar. During its best years in the 1980s, their membership roster grew to show over 1,000 individuals paying dues. In this photograph taken in 1967, seated are, from left to right, Estela Feliciano, Carolina Perlas, Juliet Leben, and Isabel Cariño; (standing) Vincent Perlas, Lily Tactaquin, Julian Llanes, Art Tactaquin, Noming Llanes, and Frank Cariño. Not in the photograph were Tim Feliciano, Santiago Tabino, and Guadalupe Tabino, who died before this picture was taken. (Courtesy Anthony Cassera.)

Shown here are some of the pioneer presidents of FAAPV. They were, from left to right, Andy Lucas, 1967–1968; Estela Feliciano, 1965–1966 and 1973; Vincent Perlas, 1959–1960; and Glenn Leben, 1963–1964. Missing from the photograph is Santiago Tabino, who was the second president from 1961 to 1962. (Courtesy Anthony Cassera.)

As the second president of the Filipino American Association at his installation party in 1961, Santiago Tabino (right) dines with wife, Guadalupe, and daughter Julie. He instituted monthly dances during his leadership, much to the enjoyment of members, so much so that succeeding leaders institutionalized them through the various potlucks, dances, luaus, and other celebrations since. (Courtesy Myrna Perkins.)

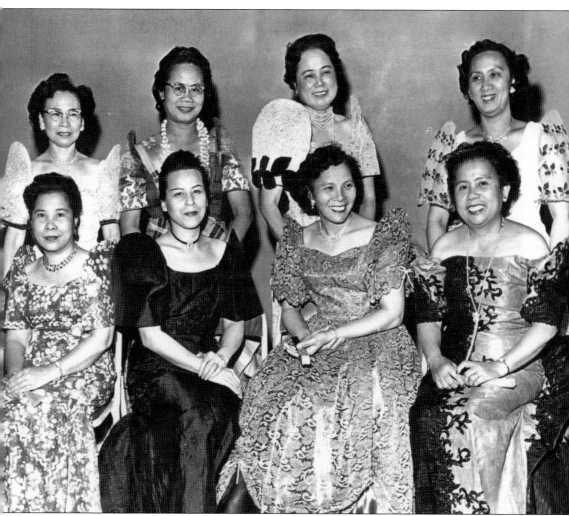

At a social program of the Filipino American Association, these glamorous ladies pose for a souvenir picture around 1960. Notice the beautiful *ternos*, the traditional formal attire for women with distinctive butterfly sleeves. Especially then, these dresses had to be brought in from the Philippines, as local seamstresses were unfamiliar with the design and pattern. As seen in their happy faces, they were always excited for these social gatherings, as it was always reminiscent of dances back home. From left to right are (first row) Angie Evangelista, Violet Hufana, Marcelina Pimentel, and Concordia Hortaleza; (second row) Amada Soy, Salvacion Leyson, Rosalia Tactaquin, and Estela Feliciano. (Courtesy FANHS-OR.)

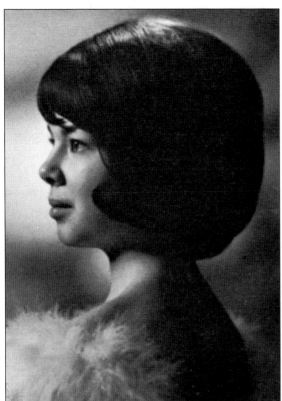

The first Miss Philippines coronation for the FAAPV was held in 1963 in a dinner and dance event dubbed "Philippine Night." This beautiful profile of lovely Marcia Alviar justifies her crowning as "Queen Marcia I." In this pageant, which remains one of FAAPV's more popular programs, Marcia was thus named the first Miss Philippines. (Courtesy Anthony Cassera.)

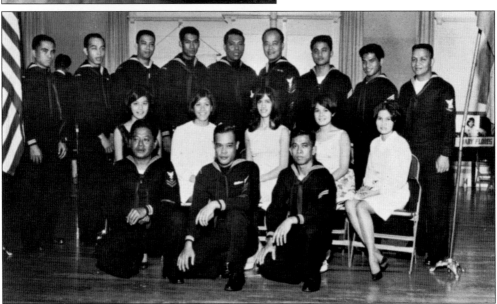

When the navy sails into town and Filipino sailors are aboard, you can be sure that the Filipino American Association will receive and entertain them. These sailors were special guests at the First Tabulation Dance in November 1967 for the Miss Philippines popularity contest. The five candidates were, from left to right, (second row) Mary Flores, Jean Rivera, Tina Pulido, Kay Bailey, and Sylvia de la Cruz. (Courtesy Anthony Cassera.)

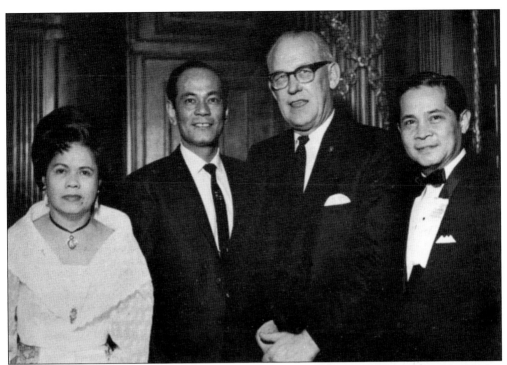

The Filipino American Association held the annual Installation Dinner-Dance at the Roaring Twenties Room of the Hoyt Hotel on February 19, 1967, with Portland mayor Terry Schrunk as a special guest. In the photograph are, from left to right, Jojo Retuta, co-owner with husband of Danny's Fine Foods Restaurant; FAAPV vice president Tony Bailey; Mayor Schrunk; and FAAPV president Andy Lucas. (Courtesy Anthony Cassera.)

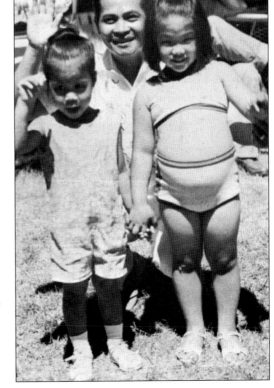

At right, Jacqueline Cariño (left) and Dolly Flores were happy to have their picture taken with FAAPV president Andy Lucas in 1967 after being announced as winners of another popular baby contest held at the annual Fourth of July picnic at Blue Lake Park in Portland. (Courtesy Anthony Cassera.)

49

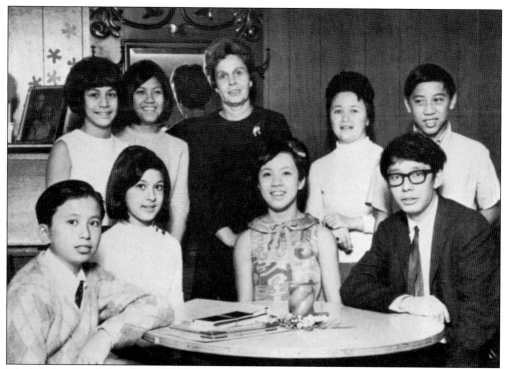

The Filipino Youth Auxiliary (FYA) was organized in the spring of 1967 and was active in all the social and cultural activities of the Filipino Americans. Shown here are, from left to right, (first row) Johnny Soy Jr., Roxanne Alviar, Gloria Jean Delfin, and Tony Cassera; (second row) Jean Galvez, Jean Rivera, Andy Alviar, Gloria Delfin, and Jeffrey Gonzales. (Courtesy Anthony Cassera.)

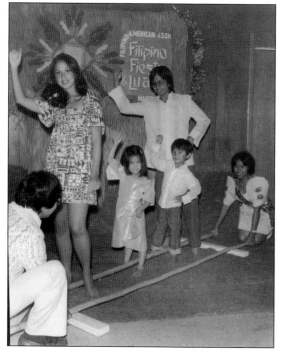

The Filipino American Association held activities to keep children of members involved. In the 1974 Filipino Fiesta and Luau, dancers Roxanne Alviar and Johnny Soy Jr. teach the little ones, Michelle Cariño and Cleto Lalic, the *Tinikling* dance, while Adela and Fernando Sacdalan clap bamboo poles to the rhythm. (Courtesy Anthony Cassera.)

The Filipino Fiesta and Luau and other Filipino American events always provided the opportunity to socialize among Filipinos of all ages. Shown here, the young adults enjoying the moment in 1972 were, from left to right, Barbara Affleck (partly cut), Danny Ramirez, Disraeli Cassera, Liz Feliciano, and Tony Cassera. (Courtesy Anthony Cassera.)

At this 1973 installation dinner held at the Top of the Cosmo Restaurant, this groovy group of young adults gathers for a photograph. Shown are, from left to right, guest Virgie Drummond, Disraeli Cassera, Medy and Rudy Bocala, unidentified, Liz Feliciano, and Dan del Rosario. (Courtesy Anthony Cassera.)

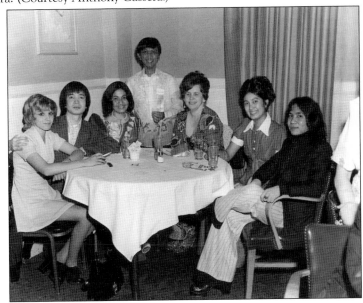

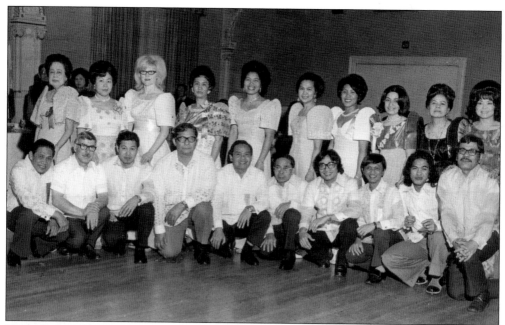

To mark the 15th anniversary of FAAPV, guests danced the choreographed Rigodon de Honor. The men are, from left to right, Art Tactaquin, Glenn Leben, Jaime Lim, Feliciano Magno, Willie Olandria, Frank Cariño, Ferdie Sacdalan, Rudy Bocala, Danny Ramirez, and Tony Bailey; (the women) Lily Tactaquin, Tsune Leben, Joyce Lim, Estela Feliciano, Betty Alvarado, Isabel Cariño, Adela Sacdalan, Medy Bocala, Joven Retuta, and Nora Bailey. (Courtesy Anthony Cassera.)

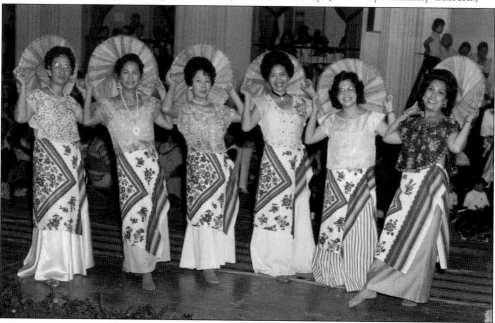

The Filipino dance Salakot (which translates to mean traditional native straw hat) was performed during the 1977 Miss Philippines pageant by these beautiful ladies in costume. Gladly posing in dance form, these women are, from left to right, Estela Feliciano, Isabel Cariño, Tsune Leben, Betty Alvarado, Lydia Lalic, and Letty Kort. (Courtesy Anthony Cassera.)

Catherine Cassera (left) and Carolina Perlas are resplendent in their native Filipino terno dresses during the 1975 Fiesta and Luau celebration. The dresses follow the traditional design pattern but use modern cotton or silk material with floral print reflecting Hawaiian influence. The traditional terno is usually sewn from banana, pineapple, or abaca fibers. (Courtesy Anthony Cassera.)

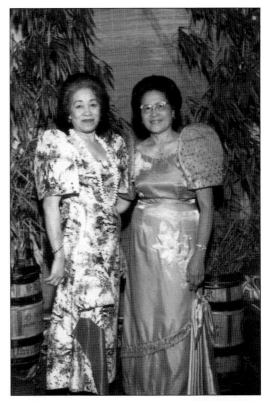

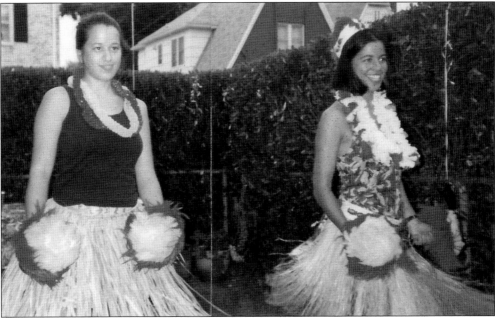

The Hawaiian hula is a popular dance among Filipinos, even in the Philippines. Next to the native *Tinikling* bamboo dance, it is performed quite frequently. Shown here are sisters Maria (left) and Julia Markley entertaining guests at the 60th birthday party of their mother, Lourdes. (Courtesy Simeon D. Mamaril.)

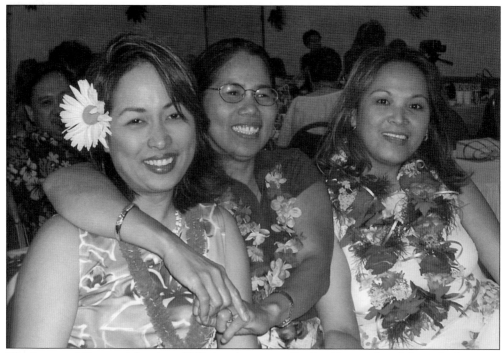

The Luau and Fiesta celebration of Filipino American Portland has endured through the years. Three beautiful ladies grace the 2002 celebration in the photograph above. Shown enjoying yet another luau are, from left to right, Gina Braganza, Amy Reyes, and Amy Aguinaldo. Although the luau is a Hawaiian feast featuring food and entertainment, it is embraced and enjoyed by the Filipinos as another fun-filled tradition. (Courtesy Anthony Cassera.)

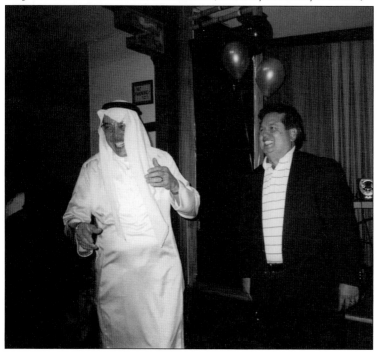

Standing here next to Bob Bayot is the prior president of Filipino American Portland Charlie Catala, dressed as an Arabian millionaire in yet another festive costumed celebration. Charlie was dubbed the "singing president" for his excellent and entertaining renditions of Frank Sinatra songs at the Fil-Am Center in the 1990s. (Courtesy Simeon D. Mamaril.)

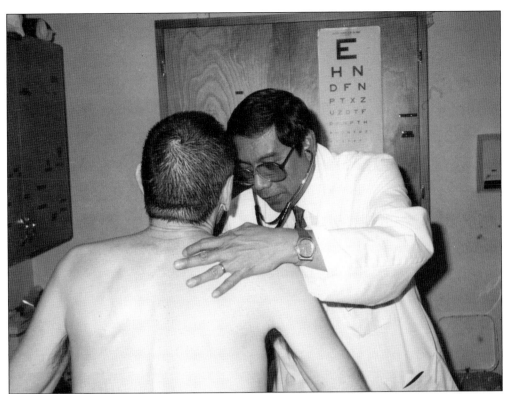

Dr. Renato Pizarro immigrated to the United States in 1972, landing in San Francisco to continue his medical studies. Upon learning about and meeting an uncle, Marciano Pizarro in Oregon, he was encouraged to settle and stay in Portland. His wife, Bella, and children followed a year later. (Courtesy FANHS-OR.)

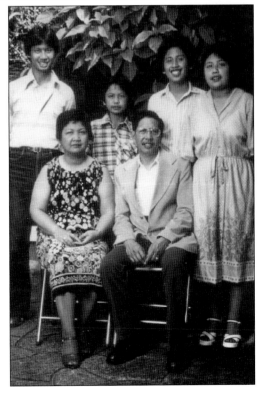

Pat Lagbao, seen here in 1980 with husband Martin and children Martin III, Mark, Marne, and Agnes, applied for a professional visa in Manila. She arrived in Portland in September 1969. Now retired and living in Henderson, Nevada, the Lagbaos enjoy the fruits of their immigrant labor. The three sons reside in California; only the youngest daughter Agnes still lives in Portland. (Courtesy Pat Lagbao.)

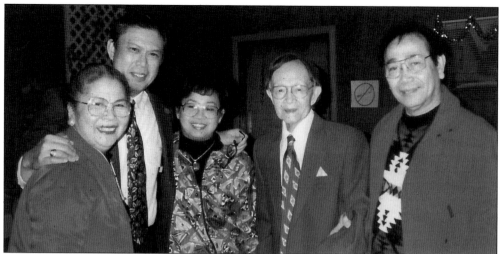

On Father's Day in 1973, Vincent Perlas (second from right), the founding president of FAAPV, celebrates with some friends and family at the Filipino American Center on Stark Street. Posing with him here are, from left to right, friend Isabel Cariño, son Richard, daughter-in-law Nenita, and friend Nani Mangalindan. (Courtesy Simeon D. Mamaril.)

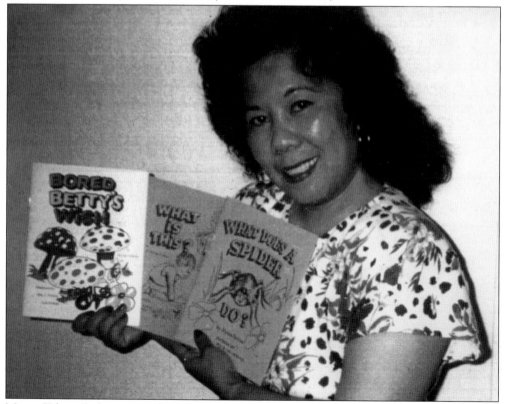

Myrna Tabino Perkins, an author of children's books, is self-educated in art. Her artworks in oil, watercolor, ink, charcoal, and dried foliage and flowers have been exhibited in different venues around Oregon. Her books have also been published in Japan and Canada and are used in public schools. (Courtesy FANHS-OR and Myrna Perkins.)

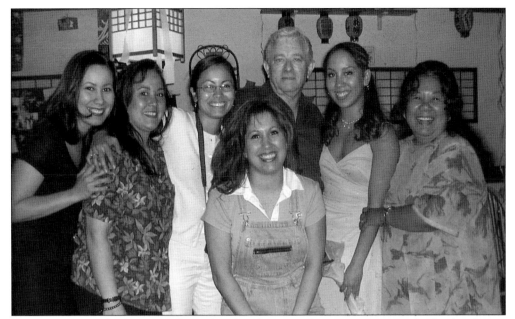

Myrna (right) and Bill Perkins have five daughters. In this 2000 photograph, the family was celebrating Tabi's graduation from Franklin High School. The girls are, from left to right, Jodi, Tami, Lori, Lani, and Tabi. The party was held at the Takahashi restaurant where Lani worked as manager, as did the other sisters at some point in their younger years. (Courtesy Tyrone Lim and *MagNet*.)

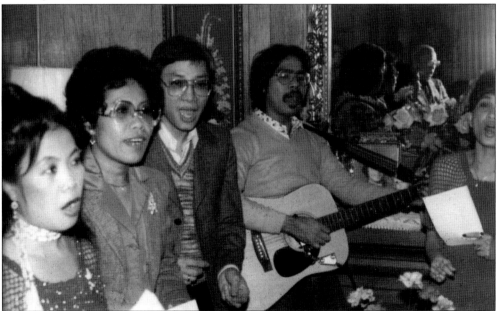

By the 1980s, Christmas celebrations among Filipinos had divided into manageable numbers, although there was still the big annual Christmas program of the Filipino American Association. Smaller groups of friends and relatives started the Simbang Gabi (Evening Mass) tradition and caroling in individual homes. Here are, from left to right, Pat Patton, Adela and Ferdie Sacdalan, Roger Cabusao, and Mila Castro caroling. (Courtesy FANHS-OR.)

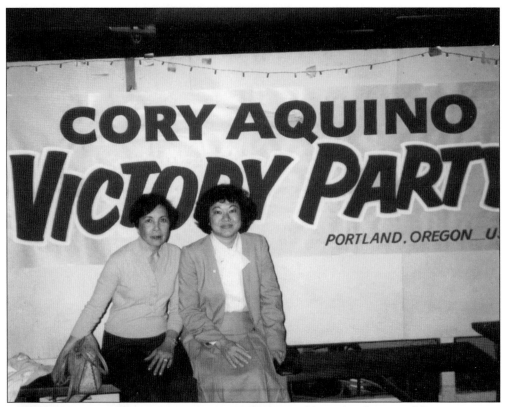

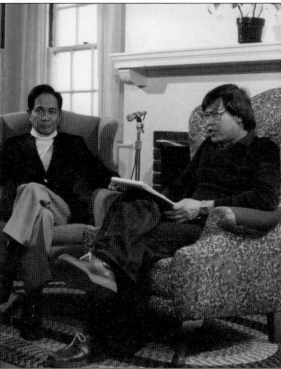

Upon the election of Corazon Aquino as the next president of the Philippines after the tumultuous, but peaceful, People Power Revolution in February 1986, an emotional victory party was gathered by Filipino supporters led by Jaime Lim at his grocery-restaurant in Portland. Among them were Fenina Fink (above, right) and Marcelina Pimentel, then president of the Filipino American Association. (Courtesy FANHS-OR.)

The surge of opposition support against the presidency of Ferdinand Marcos in the Philippines was bolstered by the appearance of exiled senator Raul Manglapus (left) in Portland in 1982, here being interviewed by Jaime Lim at the Reed College campus. This was video taped by Tony Cassera and broadcast on a public access cable channel. (Courtesy Anthony Cassera.)

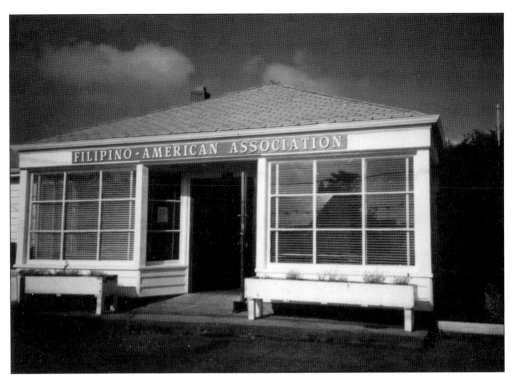

The Filipino American Association Center, located at 8917 Southeast Stark Street in Portland, was purchased in 1971 from the American Legion with a bank loan guarantee by Ken Roberts. Roberts gladly assisted because his cook at the time was Silvestre Pulmano, president of the association for 1969–1970, 1979, and 1981. Because of the amount of the loan—$60,000—all the presidents from the 1970s up to the early 1980s undertook intensive fund-raising activities. The building still stands and continues to host numerous events, even beyond the Filipino American community. The photograph at right shows Pulmano (bottom left corner) with Filipino community friends in the early 1980s. (Both, courtesy FANHS-OR.)

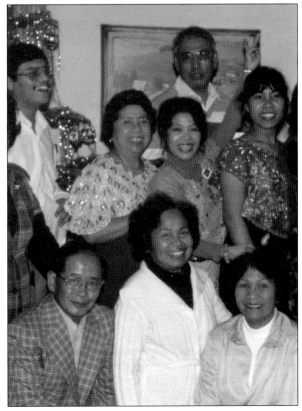

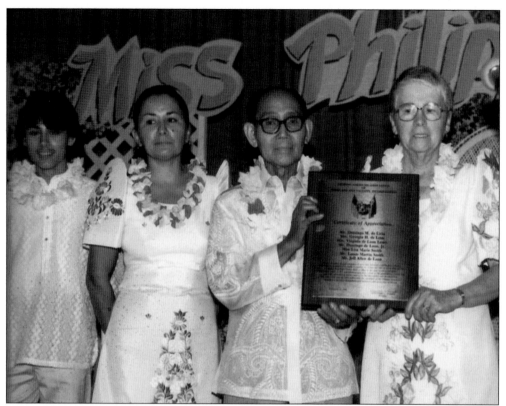

Prominent Filipino American Association of Portland and Vicinity member Domingo de Leon and his family donated $6,000 to pay off the remaining mortgage on the Filipino American building in 1984. In appreciation, the De Leon family was presented with a memorial plaque in a special ceremony during the Miss Philippines pageant, and with it the sincere thanks of a grateful community. (Courtesy Anthony Cassera.)

In a fund-raiser at the Filipino American Association Center to establish the FANHS-OR in 1988, Frank Gonzales (middle) and Tony Cassera had a mini-reunion when they cooked and catered a special dinner with the help of Tony's wife, Barbara Affleck. Both Tony and Frank were cooks at the revered Danny's Restaurant more than a decade earlier. (Courtesy Anthony Cassera.)

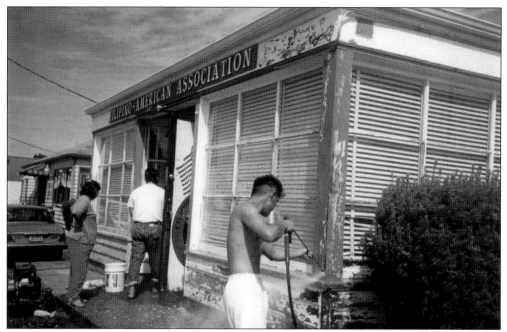

Volunteers strip the Filipino American building facade for repainting and maintenance in 1995. Originally a rabbit meat processing plant, the interior flooring of this building slopes to one side. Continuous talks and plans are considered for serious renovations to this structure in order to accommodate the growing needs of the Filipino American community. (Courtesy Tyrone Lim.)

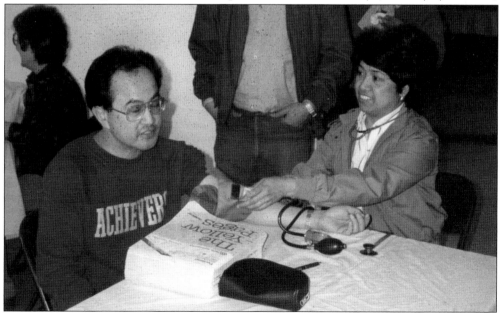

The influx of new immigrant members provided the opportunity for the Filipino American Association to introduce new volunteer programs for the community. Among the new services was a free clinic providing basic medical aid, which was introduced in 1988. This photograph shows Fred Asa, president of the association at that time, getting his blood pressure checked by Dr. Evelyn Medrano. (Courtesy FAAPV.)

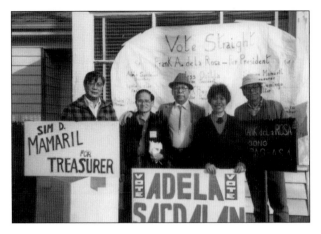

Elections for FAAPV posts became a contentious matter starting in the late 1980s, even creating opposing political parties. In the 1991 election year, the Bagong Pag-asa (New Hope) Party fielded the candidates, from left to right, Jess Osilla, Simeon Mamaril, Frank de la Rosa, Adela Sacdalan, and Rudy Mortera. They lost to Bob Asa, the winning candidate for president, and his Achievers Party. (Courtesy Simeon D. Mamaril and FAAPV.)

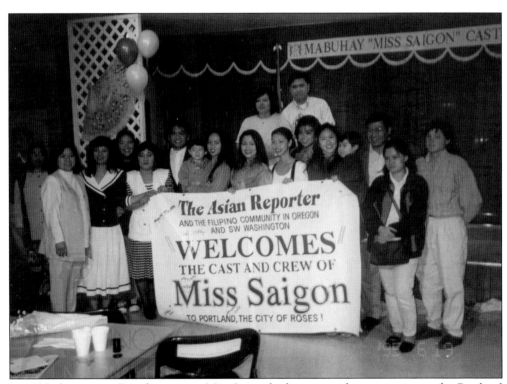

In 1995, the touring Broadway opera *Miss Saigon* had a two-week engagement at the Portland Civic Auditorium. Filipino actors in New York and Hollywood were cast as Vietnamese characters, including the lead role of Kim. The Filipino American Association and *The Asian Reporter* newspaper hosted a reception for the Filipino cast and folks from the Portland Opera. (Courtesy Tyrone Lim.)

Ferdie Sacdalan escorts the two living pioneers of the Filipino American Association, Isabel Cariño (left) and Estela Feliciano, during the 43rd foundation day celebration in 2002. Isabel is also the last one remaining of the original group of war brides of World War II who made Portland their home. (Courtesy Tyrone Lim and *MagNet*.)

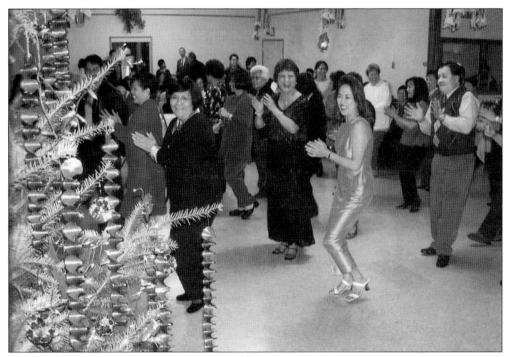

The main hall of the Filipino American building is perfect for line and group dancing. At the 2002 Christmas party, enjoyment is very much in the air. During other ordinary days and nights, the hall is sometimes used as dance rehearsal space. The association rents it out to private parties to help defray maintenance and utilities. (Courtesy Tyrone Lim.)

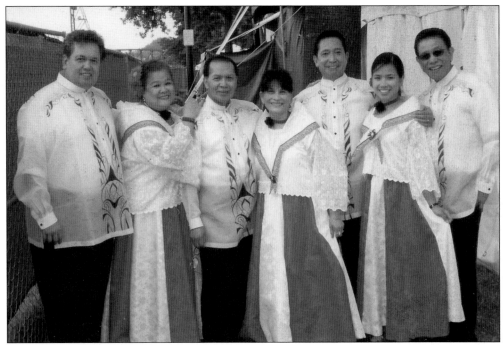

The Filipino American Association's Maharlika Dance Troupe performed at the Waterfront Rose Festival in 2009. They are just one of the many performing dance groups who are frequently invited in cultural shows throughout the state. The dancers include, from left to right, Bob Bayot, Ruth Reyes, Fely Martin, Mila Castro, Danny Acantilado, Cara Nilagan, and Ben Avecilla. (Courtesy FAAPV and Bob Bayot.)

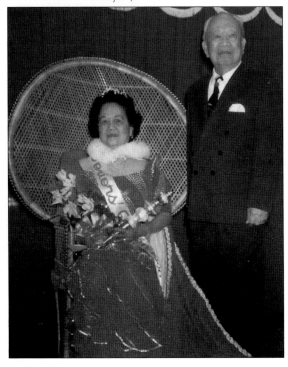

Dolores Flores, shown here as Filipino American Portland's Senior Prom Queen for 1996, was the president of the association in 1977. Her husband and escort, Alex, served as president for eight years in the 1970s and 1980s. He was a soldier with the 1st Filipino Infantry Regiment during World War II, and she was his war bride. Alex passed away in 1997, she in 2002. (Courtesy FAAPV and Simeon D. Mamaril.)

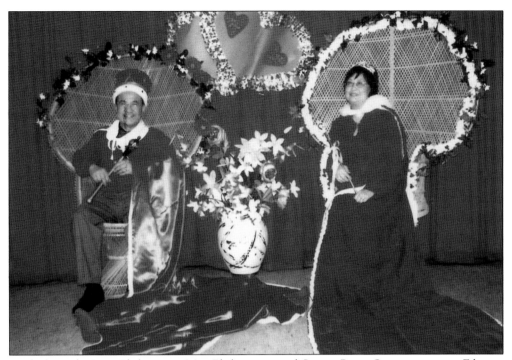

Aside from the Miss Philippines, Mrs. Philippines, and Senior Prom Queen pageants, Filipino American Portland also launched the Mr. and Mrs. Philippines pageant. Needless to say, Filipinos love pageantry and all types of coronation events. Fred and Beth Asa beam with happiness as they are crowned Mr. and Mrs. Valentine 2009 at the Filipino American Center. (Courtesy Simeon D. Mamaril.)

When the Philippines passed a law granting Filipino citizenship to those who had lost it through immigration and naturalization, the San Francisco Consulate conducted an outreach program to process applications. The consulate staff came to Portland in 2008 to process over 200 dual citizenship applicants; in 2009, it added Eugene and Salem to its itinerary. (Courtesy Simeon D. Mamaril.)

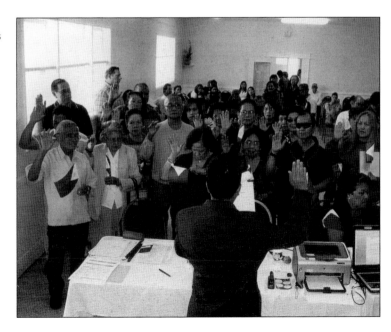

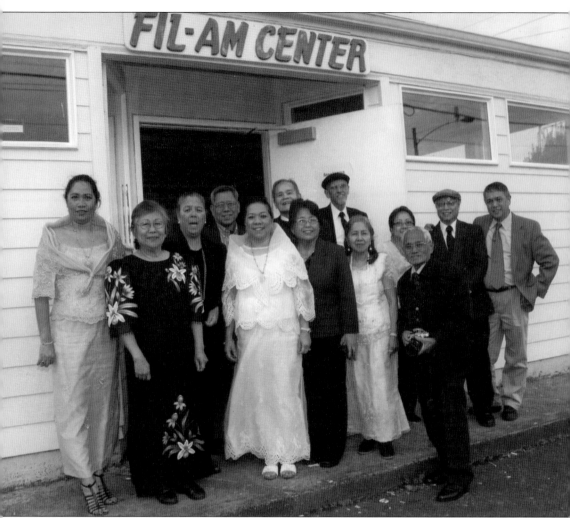

Filipinos ready for a party gather in front of the Filipino American Center. The facade and signage of the structure were refurbished to give the center an updated look. Gathered here for this photograph opportunity are members and guests of the Filipino American National Historical Society Oregon Chapter. It is common for modern event attires to include both Filipino traditional and American style, unless of course there is a specific theme to the event. From left to right are Lourdes Zakzrewski, Medy Saqueton, Marisa Newnam, Lito Saqueton, Fonjie Lim, Willie Olandria (slightly hidden), Ruth Olandria, Al Newnam (in dark cap), Ciony Arroyo, Dolly Specht (partly hidden), Simeon Mamaril (holding camera), Ferdie Sacdalan, and Ronnie Lim. (Courtesy Dolly Specht.)

Four

A GROWING COMMUNITY

By the 1970s, the Filipino population in the valley was booming, reflective of the increase in immigrant quotas passed in 1965. They all started coming, and doctors, nurses, engineers, and accountants were in a different preference category from family-based immigrants. All Filipinos in America had a family to petition. Other entry categories were available as well: political asylum seekers, business investors, students, fiancées, and of course, tourist visas.

The Filipinos formed more associations wherever they were. One such is the Greater Salem Filipino American Association (GSFAA), which was created by pioneers in the 1970s but became inactive a few years later. It was revived in 1990 by a group of young families who moved to the area in the 1980s.

In Eugene, a little *salo-salo* (gathering involving light snacks) in 1973 led to the establishment of the Philippine American Association of Eugene and neighboring Springfield. For a short while, PAA had a satellite group in Roseburg, south of Eugene. In 2000, Roseburg residents established the Douglas County Filipino American Association.

Back in the growing Portland area, the arrival of more professionals (the "brain drain") shifted the dynamic within the Filipino community. Philosophical differences forced some members to form smaller get-togethers. One such informal group was an association of professionals. On the west side of town, residents decided in 1978 to form the Filipino American Friendship Club of Oregon, with special emphasis on young people's role in fulfilling the club's objectives and goals.

Across the Columbia River and the Washington state line, Vancouver Filipinos established the Filipino American Association of Clark County and Vicinity (FAACCV) in the early 1980s to preserve the 'old country' culture and camaraderie.

In Corvallis, while Gideon Alegado was student services manager at Oregon State University advising the Filipino student association Isang Bansang Pilipino (IBP), he and other Filipino residents decided to start the Willamette Valley Filipino Association (WVFA) in 2001.

Several other smaller cities in the valley formed their own Filipino groups. All together, these community organizations filled the need to reach out and keep in touch with fellow Filipinos, many of whom were recent immigrants still adjusting to life in America.

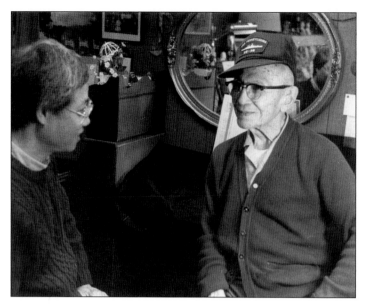

FANHS-OR curator Fernando Sacdalan interviews Mac Lustre of Astoria, Oregon, in 1988. During the early years of the chapter, members fanned out across the state to conduct oral histories of Filipino pioneers, documenting all stories told. They also collected old photographs for posterity to build its archives. (Courtesy FANHS-OR.)

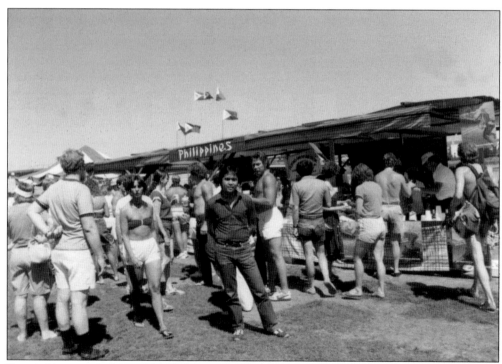

Ronnie Lim poses in front of the Philippine food booth at the 1984 Bite of Portland. Summertime in Portland brought in a fleet of navy ships as part of the attraction of the world-famous Rose Festival. With these ships were Filipino sailors and crewmen. Business and reception committees of the various Filipino organizations were quite eager to take them around. (Courtesy Tyrone Lim.)

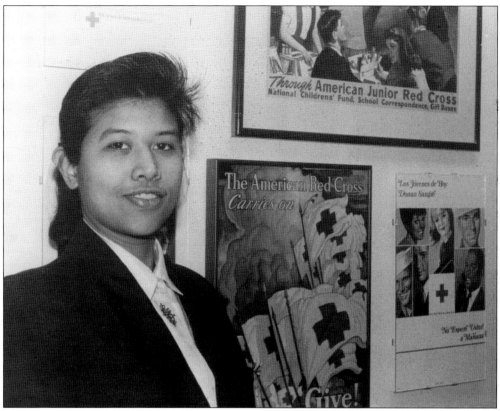

These two pictures were among those taken in 1988 when FANHS-OR started collecting photographs of community members for archiving. Maryanne Avecilla (above) worked with the Red Cross and Mila Vasquez (below) with the U.S. Postal Service. They are among the growing Filipino immigrants positively contributing to the diversity of America. (Both, courtesy FANHS-OR.)

School-age Filipino immigrant children like Ricci (left) and Punky Lim, in 1988, quickly adjusted to a new environment in America. They did not, however, have to learn a new language, because until the late 1990s, English was the main medium of instruction in Philippine schools. By the year 2000, a surge of national pride changed it to Filipino based on Tagalog. (Courtesy Tyrone Lim.)

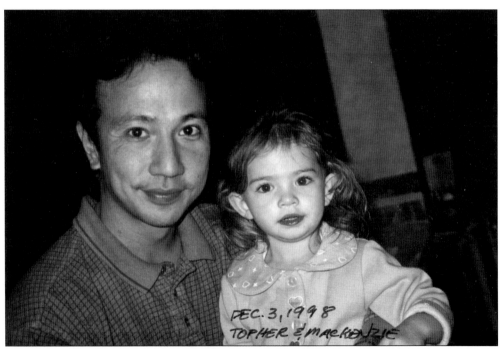

Christopher Ancien (with daughter Mackenzie in 1998) came to America in 1980 when he turned 26. That was the age when a person born in the Philippines to an American parent chose between a Filipino or American citizenship. He chose the latter. Today Philippine law allows dual citizenship for Filipinos abroad who had lost their citizenship due to naturalization. (Courtesy Jo Knerr.)

70

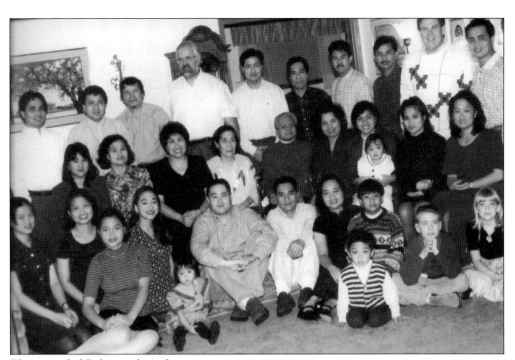

The extended Pulanco clan of Oregon traces their American origin to one Victor Lomboy, a brother of clan matriarch Juana Galvan Lomboy, one of a group of men in a photograph that graced the cover of the 2000 FANHS-OR book *Filipino Americans: Pioneers to the Present*. Victor Lomboy was the first family member to come to America, leaving the Philippines in 1926 for a job at a Hawaiian sugar plantation; he was 19 years old. Some of his siblings, including sister Juana, came to America on their own after hearing about the good life that Victor was leading. Fast-forward to 2002, and one of Juana's granddaughters, Jackie Fernandez, was blazing her own trail as the main story of *MagNet* magazine in its October issue. (Both, courtesy Tyrone Lim and *MagNet*.)

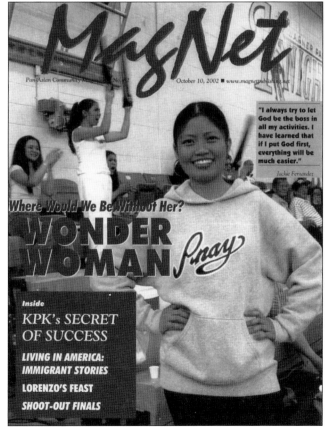

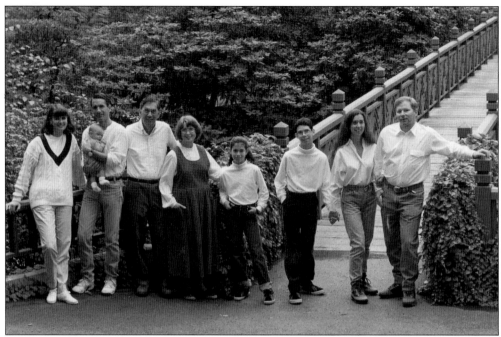

Filipino blood is thinning out with each new generation in the Guimary family. Ray, the family patriarch, is half Filipino; his mother was Swedish. In this 1996 family photograph are, from left to right, daughter Jennifer; her husband, Tony, carrying baby Claire; Ray and his wife, Mary Ellen; granddaughter Jena and grandson Karlton, both children of daughter Jeani and her husband, Karl. (Courtesy Ray Guimary.)

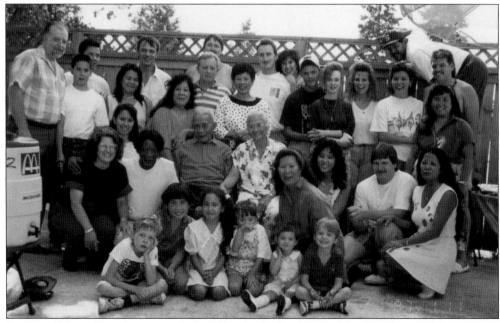

Santiago Tabino (seated center in dark, collared polo shirt), one of the founders of FAAPV, enjoys a party in 1992 surrounded by his multiracial descendants, who span five generations. He died at the age of 94 in 1999. Married twice, he had a total of 12 children. (Courtesy Myrna Perkins.)

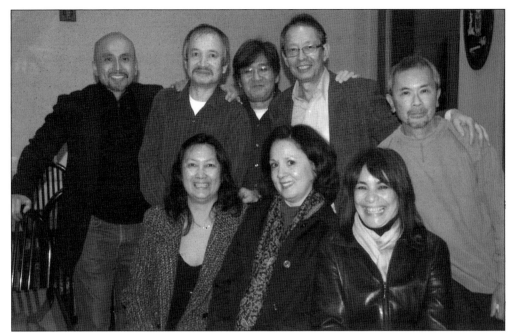

The Cassera brothers and their wives gather for a reunion. Their father, Francis Cassera, was a British civilian in Manila during World War II. He was partially blinded during his Japanese concentration camp captivity. After liberation, he met and married Catherine Rubio. He came to Portland in 1960, and eye doctors restored his sight three years later so he could watch his three boys, Eric, Anthony, and Disraeli, growing up. (Courtesy Anthony Cassera.)

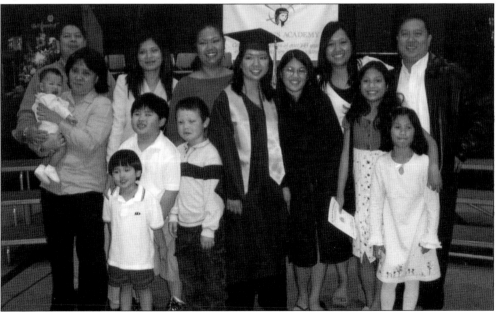

The next generation of the Lim family is amply represented in this photograph of Fides Lim graduating from high school in 2005 surrounded by her sisters, cousins, aunts, and uncles. The immigrants arrived one after another in the 1980s, leaving homes, careers, family, and friends for a new life in America. (Courtesy Tyrone Lim.)

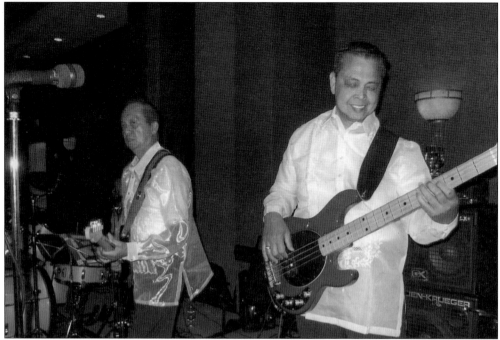

The Manila Band musicians Jimmy Salarzon (left) and Steve Barce play at the 2009 Barong and Terno Ball in Beaverton. The band is among the most sought-after musicians in the community over the years, performing regularly in hotels and venues like the Elks Club. The two other band members are Philip Barce and Rafael Dones. (Courtesy Anthony Cassera.)

Multitalented with musical instruments, Diony Arellano plays the guitar, trumpet, and saxophone. In this photograph, he applies his nimble fingers to a soundboard as he deejays at a function in the 1970s. Together with Alberto Asprec, he composed the FANHS-OR theme song, with lyrics written by Simeon D. Mamaril. (Courtesy Anthony Cassera.)

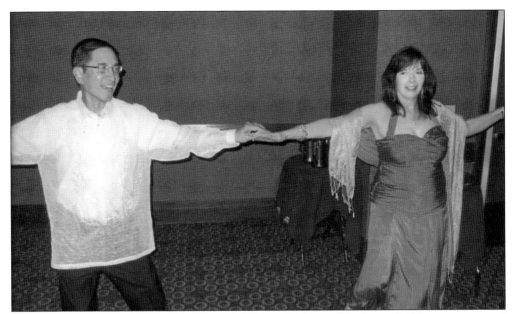

With the Filipino's love of music naturally comes the love of dancing. A Filipino-sponsored event will not be complete without the usual choreographed dances in any form, from cultural to ballroom. Here Peter Sanchez and his dance partner show off some moves, sans dance floor. (Courtesy Simeon D. Mamaril.)

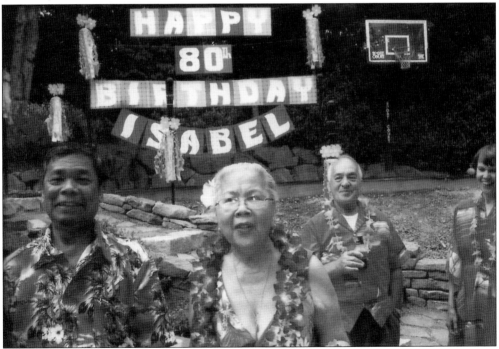

Isabel Cariño celebrated her 80th birthday in 2008 with a luau in daughter Jackie's backyard in Beaverton. Escorting Isabel is Mario Balangue, a former bartender at the University Club in Portland. Isabel is also the last remaining war bride who arrived immediately after World War II, making Portland her home. (Courtesy Simeon D. Mamaril.)

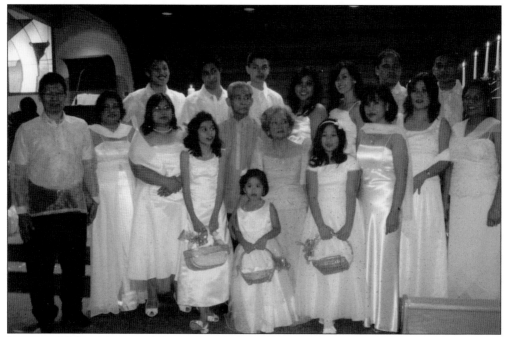

Jovito and Felisa Marzan celebrate their 50th wedding anniversary in January 2010 with their children and grandchildren. In the Filipino community, it is common for special wedding anniversary celebrations to include renewal of vows on the 25th, 50th, and 75th years of marriage, although we have yet to witness a diamond anniversary. (Courtesy Simeon D. Mamaril.)

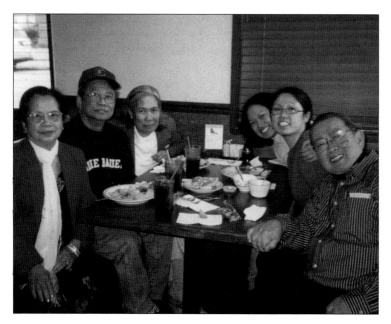

This group of friends dines at China Moon Restaurant in Portland to celebrate the photographer's 80th birthday in 2005. Happily greeting Simeon D. Mamaril, a beloved elder in the Portland community, are, from left to right, Celerina Madarang, Edilberto and Ruth Veniegas, sisters Edith and Ruby Veniegas, and Leon Madarang. (Courtesy Simeon D. Mamaril.)

Eva Lumba turned 90 in 2003. She studied dressmaking in the Philippines, then worked at the I. Magnin Store in Portland. Eventually wishing to have a college degree like her children, Eva later enrolled and graduated at Portland Community College at the age of 75. She was honored as the oldest member of her class in 1988, even delivering the commencement speech. (Courtesy Anthony Cassera.)

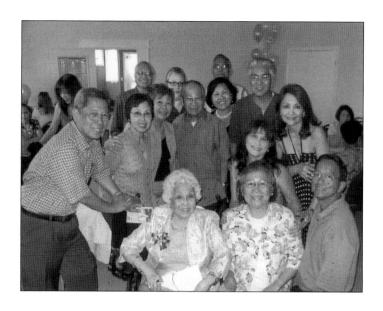

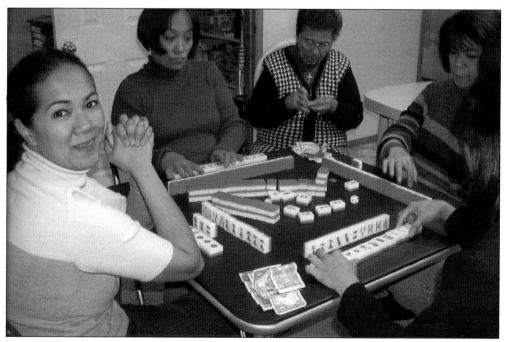

Pictured from left to right, Kim Lauzon, Tina Santos, Lourdes Lauzon, and Gladys Gang play mahjongg. Fans of this Chinese import to the Philippines attest to its relaxing attributes. Although it involves a certain degree of skill, strategy, and calculation, mahjongg is one of the top parlor games in the old country and is popular among Filipinos in America. (Courtesy Tyrone Lim.)

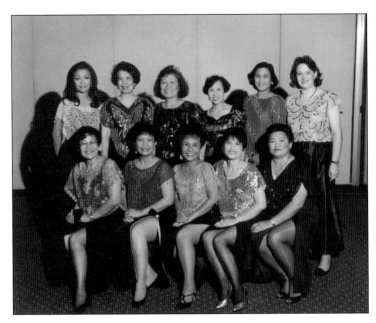

These were the female leaders of the Filipino American Friendship Club in 1993. Daring in their high slits, they glamorously pose in this formal affair. Seated are, from left to right, Bennie Ramirez, Gloria Rivera, Myrna Boyce, Mila Castro, and Naty Flores; (standing) Loida Gonzales, Chit Tamola, Medy Saqueton, Flor Irlandez, Nora Madarang, and Barbara Affleck. (Courtesy FAFC and Anthony Cassera.)

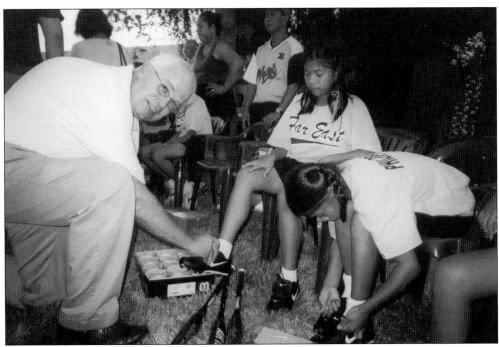

Larry Johnson tries a new pair of shoes on a player with the Far East team. Alpenrose Stadium in Portland hosts the annual Little League World Series for girls, and FAFC members welcome them through a homestay program. The Philippines always represented the Far East or Asia Pacific region. (Courtesy FAFC.)

Jay Rivera (left) and Jeremy Madarang gleefully wear native Filipino clothing in the 1994 Good Neighbor Days Parade. The friendship club participates in various civic activities not limited to just the Filipino community to show that they are part of the mainstream. The Good Neighbor Days is an annual celebration in Beaverton. (Courtesy FAFC.)

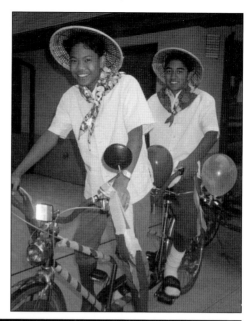

Myrna Boyce (center, with husband Butch and Dolly Specht) is one of the prime movers of the Filipino American Friendship Club of Oregon. Myrna was 10 when her father was appointed to open the Philippine consulate in Honolulu. As an English as a Second Language (ESL) teacher in the Tigard Tualatin school district, she was nominated to the Who's Who Among American Teachers. (Courtesy Anthony Cassera.)

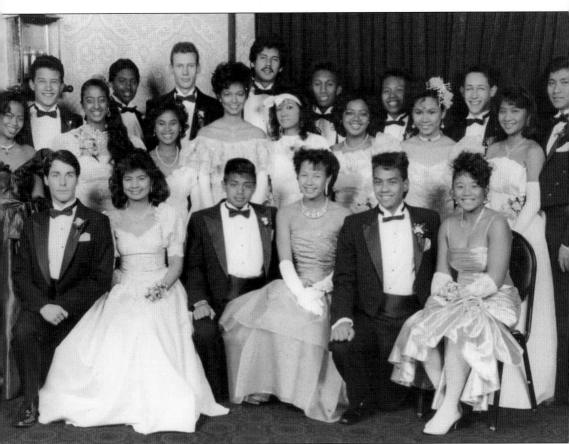

The first time the friendship club held the debutantes ball was in 1986. Because of the extensive planning involved, they decided to hold it every other year. It was a majestic display of Filipino pomp and class, usually celebrated upon a girl's 18th birthday. Young ladies were chosen to participate for this coming-out event, featured as debutantes of the Filipino community. The ladies shown with their escorts in this photograph are (seated) Gail Alviar, Maple Chiong, and Rosemary Chiongbian; (standing) Vicky Corpuz, Stella Dantas, Gena Dario, Pam Turla, Theresa dela Paz, Monica Gutierrez, Natalie Ladera, and Cecile Saqueton. (Courtesy FAFC and Medy Saqueton.)

A former radio talk show host in the Philippines, Myrna Boyce is very comfortable with the microphone. Here she is cohosting the 1994 debutantes ball, standing next to KOIN News anchorman Mike Donahue. As a local celebrity, Donahue's participation in our cultural event shows that our celebrations are now embraced by the greater community. (Courtesy FAFC.)

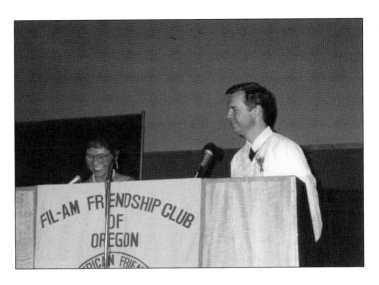

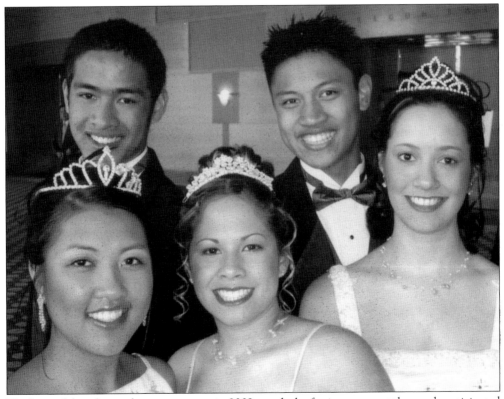

The beautiful smiles on these young ones in 2002 match the festive energy at the much-anticipated debutante balls. Pictured are three of the debutantes with their escorts. From left to right are Marie Grace Vu, Dahryll Limjuco, Michelle Carrington, Paul Vu, and Maria Cassera. In 2005, this event was replaced by the Barong and Terno Ball, another formal event showcasing glamorous Filipino attires for adult men and women. (Courtesy Anthony Cassera.)

Gloria Rivera is caught uncontrollably laughing on camera while playing a "middle-aged-wives game" at the 1984 Independence Day picnic at Raleigh Park. The young ones at the picnic noted how easy it was to make the ladies laugh. (Courtesy FAFC and Medy Saqueton.)

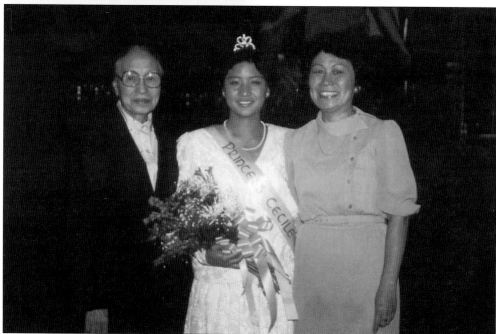

Cecile Saqueton must have truly impressed her classmates from elementary and middle school, because they voted her the Spring Reign homecoming queen of Beaverton High in 1986. They campaigned for her and Highland Park Middle School, which had not produced a beauty queen in a long time. With her are mom Medy (right) and grandma Mercedes Cajulis. (Courtesy Medy Saqueton.)

Dr. Angelito Saqueton practiced dermatology at Kaiser Permanente for 31 years. He was presented with the 1994 Meritorious Achievement Award by the Oregon Health and Science University (OHSU) for outstanding service to his field. He was chosen by his colleagues as one of the distinguished physicians in 1996. During his practice, he willingly served not only Kaiser members but also *kababayans* (Filipino countrymen) with skin problems. (Courtesy Medy Saqueton.)

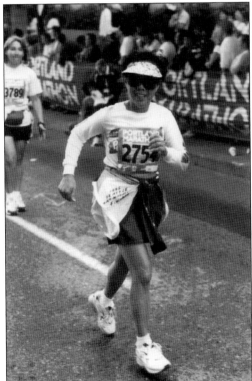

Flor Irlandez of Tigard is an avid fitness buff and has won the Portland Marathon in her age group several times. She is among the many Filipino running enthusiasts who join marathons. Flor has dedicated herself to this event regularly, following a strict regimen to prepare, beginning in the spring and culminating in the October competition. (Courtesy Flor Irlandez.)

Frank and Flor Irlandez (standing) smile here with their close friends, from left to right, Bennie Ramirez, Elma Alviar, and Marta Fama. The Irlandezes spend their retirement years shuttling between Oregon and their hometown in Marinduque province in the Philippines, where they are developing a beach resort. With Frank's engineering background, he designed the resort to become an international tourist destination, the first in the island province. (Courtesy Simeon D. Mamaril.)

The Filipino American Association of Clark County and Vicinity performs at a city park in 1988. FAACCV has served as a welcome wagon for new Filipino Americans in the area, providing assistance, if needed, and a comfortable atmosphere of friendship. And, of course, it has established the annual formal Christmas dinner/dance of the Filipino Americans in the area, Pasko Na Naman. (Courtesy FAACCV.)

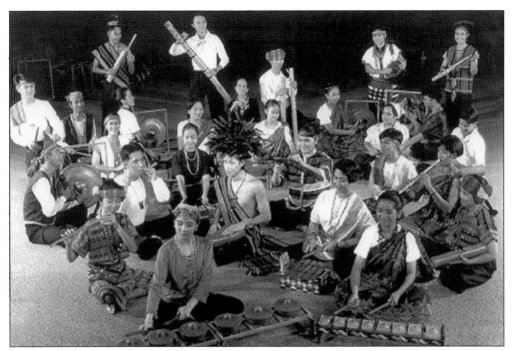

Over the years, FAACCV has sponsored visiting performing artists such as the Kontra Gapi Ensemble of the University of the Philippines (UP). It is a gamelan orchestra, using instruments native to the Filipino-Indo-Malay region of Southeast Asia. Like its fellow performers the UP Concert Chorus, Kontra Gapi engages in a world tour every two to four years, and the Willamette Valley has always been on the itinerary. (Courtesy FAACCV.)

Jo Knerr (right) and husband Michael visit with Washington state representative Jaime Herrera at the capitol in Olympia in 2009. Jo was one of the Filipinos who organized the first Filipino American association in Vancouver in the late 1970s, hosting an international potluck among friends and business associates. (Courtesy Jo Knerr.)

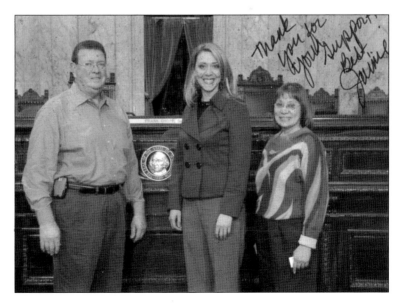

On a glorious day in Ridgefield, Washington, Mike and Jo Knerr hosted this international summer potluck in 2007. These invitees multitask by waving to the camera while holding their plates. From left to right are unidentified, Gladys Gang, daughter of Kathy Pham, Jim Griffith, Kathy Pham, Louisa Griffith, unidentified, Jo Knerr, Simin Saadatt, and unidentified. (Courtesy Jo Knerr.)

The Greater Salem Filipino American Association celebrates Philippine Independence Day on June 12 with a picnic. This marks the day in 1898 when the Filipinos declared their independence from Spain, thus creating the First Philippine Republic. The short-lived republic was effectively ended when Pres. Emilio Aguinaldo surrendered to the American forces in 1901. (Courtesy GSFAA.)

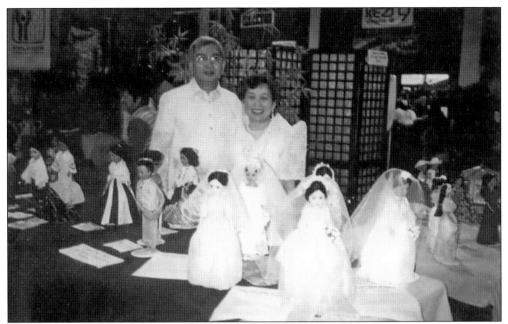

Barbie-sized dolls dressed up in native Filipina garb are the handiwork of Norma Roxas of Salem, shown here with husband Ephraim with their exhibit at the Asian Celebration in Eugene. Norma has handcrafted over two dozen different styles, all less than 20 inches. Her collection of dolls has expanded to all kinds of ethnic costumes and native clothing of women from different Asian countries. (Courtesy Norma Roxas.)

Fred Gray and Marie McHone of Salem are at the 2005 New Year's Eve party celebration at the Filipino American Center. Fred served in the U.S. Army and saw action in the Formosan crisis of 1958–1959 and the Vietnam War. He was the first president of the Greater Salem Filipino American Association when it was revived in the early 1980s. (Courtesy Anthony Cassera.)

Marisa Newnam of Salem, wearing a colorful batik number, dances with her nephew Noel Senoran. This was taken during a FANHS-OR fundraiser, Down Memory Lane, in 1991. The funds were used to help support FANHS-OR programs and activities. They attended the party with Marisa's husband, Albert, and their daughter Maryann. (Courtesy FANHS-OR.)

Angie Collas-Dean (left) and Belen Sugui cook for a joint Philippine American Association (PAA) of Eugene and Springfield event with the Kabataang Pilipino, the Filipino student association at the University of Oregon. Angie was a professional caterer and owner of Philippine Party Foods in Eugene in the 1970s and 1980s after retiring from a career in television in the Philippines. She was a cofounder of PAA. (Courtesy PAA)

Remia Johns (right) does a good job selling Filipino lunch goodies at the PAA food booth at the 2002 Asian Celebration in Eugene. The annual two-day wintertime festival features a bustling array of Asian culture through its colorful marketplace of dances, an art exhibit, crafts, martial arts, a cooking demonstration, and tantalizing Asian delicacies. Also in the booth are Nikki Relampagos (left) and Jackie Friesen. (Courtesy Mimi Nolledo and *MagNet*.)

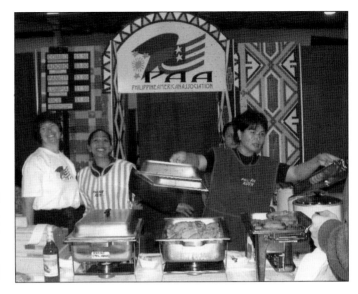

Three pretty ladies of Kultura Pilipinas (KP), the Filipino student association of the University of Oregon, are, from left to right, Mayumi Raines, Georgia Asvos, and Erika Bulay. They emceed their Cultural Night in 2002. KP is an active partner with the PAA, pushing Filipino presence in the Eugene area. They participate in many civic activities, including the popular Asian Celebration every February. (Courtesy Mimi Nolledo and *MagNet*.)

As a daughter of a Filipino diplomat, Ardyn Reyes Wolfe had lived in many places around the world before she moved to Eugene, where she stepped up as a member of the board of the Philippine American Association. When she was first elected to the PAA post, she said she was ecstatic that she had finally connected with the Filipino community. (Courtesy Mimi Nolledo and *MagNet*.)

Anselmo and Rose Mary Villanueva were both students at UCLA when they first met. They moved to Eugene in 1979, and Anselmo pursued a doctorate degree in 1992 at the University of Oregon. He is the youngest of four brothers by a German British mother and a Filipino father who came from Aklan province in 1929. (Courtesy Simeon D. Mamaril.)

During the 2006 Council of Filipino American Associations (CFAA) Convention in Corvallis, Gideon and Rachel Alegado stand with three members of the Willamette Valley Filipino Association (WVFA). From left to right are (seated) Gigi Franco, Lourdes Vogt, and Norie Vogt. The WVFA was the newest association to join the Council of Filipino American Associations (CFAA) in 2001. Gideon is now one of the permanent members of the council's board of trustees. (Courtesy Simeon D. Mamaril.)

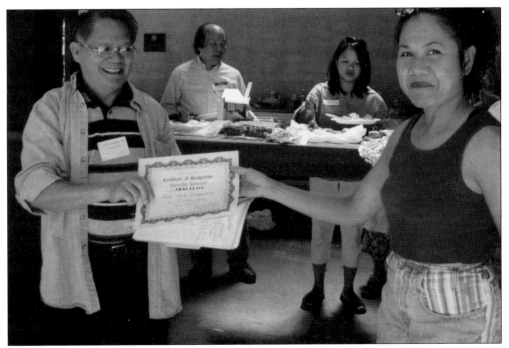

Gideon Alegado presents the first place award to Nenita Winsor at the potluck picnic cook-off in 2001. Gideon was one of the founders of the Willamette Valley Filipino Association based in Corvallis, also covering the surrounding cities of Albany, Lebanon, and Sweet Home, as well as members from Salem and Portland, when it was established in 2001. (Courtesy Tyrone Lim and *MagNet*.)

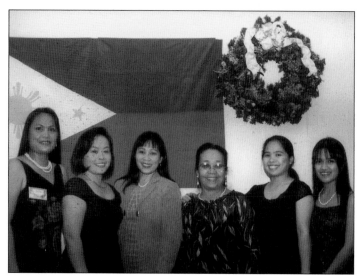

Members and guests of the Willamette Valley Filipino Association stand behind a big flag of the Philippines during the association's Christmas party in 2002. The Philippine flag is always displayed with the sun and stars on the left side. In approval of the background decor are, from left to right, Edna Hooe, Carmela Dillon, Shirly Fish, Carmela's mother, Inn Berg, and Glenda Boundy. (Courtesy WVFA.)

These individuals are multitasking members of different organizations, gathered here in 2009 as leaders of the Filipino Faith Community. They are some of the most dynamic and coordinated workers of the Filipino American community. Seated from left to right are Adela Sacdalan, Dolly Specht, and Annie Maglalang; (standing) Simeon Mamaril, Titay Schommer, Pia de Leon, Ferdie Sacdalan, Raquel Naval, Tet Pimentel, and Derick Maglalang. (Courtesy Simeon D. Mamaril.)

Five

THE FOCUS GROUPS

By the 1980s, the Filipino communities in the valley have become multigenerational. The pioneers started having their own families, so American-born Filipinos were becoming a growing segment of the community. In many cases, the clash of cultures was inescapable, primarily in the language spoken at home. There needed to be a two-way understanding of cultural traditions on one side and the American way on the other. In some multiracial families, the challenge was even greater.

The era of goal-specific organizations began in 1986, when the Filipino American National Historical Society (FANHS), a recently established entity in Seattle by Fred and Dorothy Cordova, came to Portland to pitch the creation of an Oregon chapter. Lourdes Cereno Markley, a trustee in the national organization who invited the Cordovas, became its first vice-president. Fernando Sacdalan was elected president and later became archivist.

Earlier that summer, Filipinos yearning for their dialects among themselves formed the Cebuano Speaking Organization (CSO) of Oregon and southwest Washington. It was headed by Willie Olandria, who took the position of president and chairman from 1988 to 1995.

Artist Rudy del Rosario arrived in 1984 with his own family, the last among his brothers and sisters to leave the Philippines. He established the Teatro Bagong Silangan (Theater of the New East) in 1990 with fellow artists in Portland to promote "Filipinism" through their artistic and cultural works.

The nucleus of the Aguman Capampangan was formed in 1996 through the pioneering efforts of Ernie Turla who was encouraged to start a civic-minded association of Pampanguenos (immigrants from the province of Pampanga in the Philippines).

In that same year, the Philippine American Chamber of Commerce of Oregon (PACCO) was established in adherence to a state mandate encouraging trade with Asian countries. Angie Collas-Dean was a commissioner of the Oregon Commission on Asian Affairs and instigated the formation of PACCO. She became its first president and led a highly successful trade mission to the Philippines within the first year.

As the millennium ended and the 21st century began, more focused organizations kept forming, reflecting the wide array of interests of Filipinos.

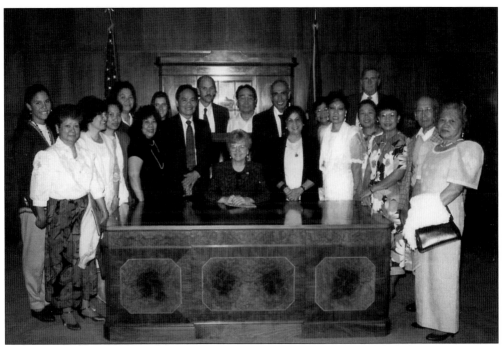

Gov. Barbara Roberts (seated) signed a proclamation in 1992 declaring October as Filipino American History Month in the state of Oregon, remembering the first recorded arrival of Filipinos to America. Every October since, the FANHS-OR conducts its annual symposium and an occasional community fair and festival in cooperation with other Filipino organizations. (Courtesy FANHS-OR.)

The FANHS-OR logo was designed by Fernando Sacdalan for its establishment on August 10, 1988. After becoming its first president, Ferdie was named curator of archives. The chapter has grown to more than 100 members in the late 1990s. With many of the original members gone, new blood trickles in with a growing interest in Filipino American history. (Courtesy FANHS-OR.)

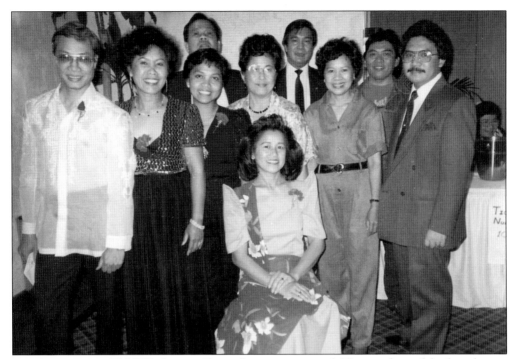

In order to create a FANHS chapter, 10 members were required. The members of the first chapter are shown here in 1988. Seated is Lourdes Cereno Markley; standing from left to right are (first row) Ferdie and Adela Sacdalan, Jemima Winquist, Ruth Olandria, Emma Yabut, and Dan del Rosario; (second row) Willie Olandria, Jess Osilla, and Rudy del Rosario. (Courtesy FANHS-OR.)

Within the first year of the FANHS-OR chapter, members had gathered enough photographs to display in an exhibit of the early Filipino Oregonians. Lourdes Markley points out one of the images on the exhibit wall set up at the Filipino American Center to her son John and husband Charles. Charles Markley was the original registered agent for the chapter. (Courtesy FANHS-OR.)

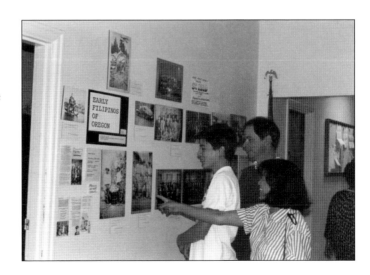

Sabrina Sacdalan models one of the native Filipina dresses on display at the Vintage Fashion Exhibition in 1991. Aside from photographs, the Oregon chapter also archives artifacts related to the Filipino American experience. Some specific items that have been loaned for display include a miniature Spanish galleon, a wooden replica of a fighting rooster, plaques of commendation, marriage and naturalization certificates, and military uniforms, among others. (Courtesy FANHS-OR.)

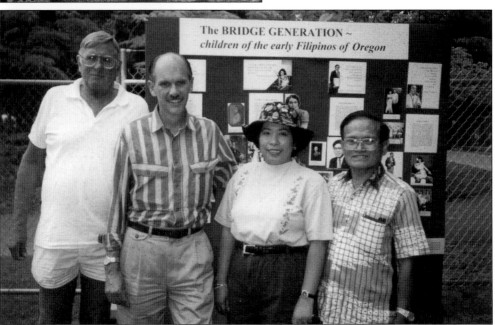

With Albert Newnam as president in 1994, the chapter presented its third photograph exhibit on the "bridge generation," children of the early pioneer Filipinos in Oregon. This also became the topic of the annual symposium in October 1993. In the photograph of the summer picnic at Creston Park are, from left to right, Calvin Newman, Al Newnam, Celestial Ward, and Simeon Mamaril. (FANHS-OR.)

Willie and Ruth Olandria are with their two sons Wil Jr. (left) and Warren during the 1992 FANHS symposium. When they were both still working, Willie was a civil and sanitary engineer in the federal government, while Ruth was a registered nurse. Wil Jr. has become an aspiring actor in Hollywood, while Warren is now a lawyer in Washington, D.C. (Courtesy Ruth Olandria.)

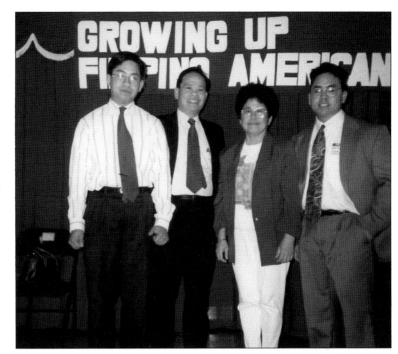

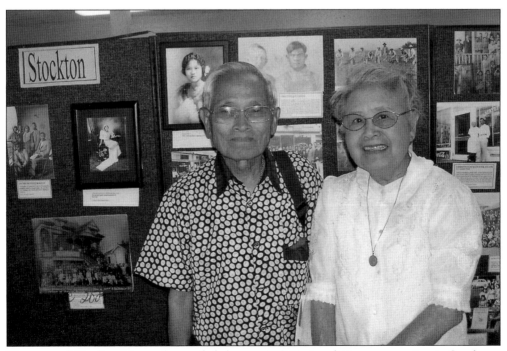

Simeon and Cording Mamaril attended the FANHS National Trustees meeting in Stockton, California, in July 2009. The Mamarils were the FANHS-OR workhorses during the 1990s, he as president from 1994 to 2000 and in 2002 and she as historian and public relations officer and editor of the newsletter *Chapter One*. (Courtesy Joan May Cordova.)

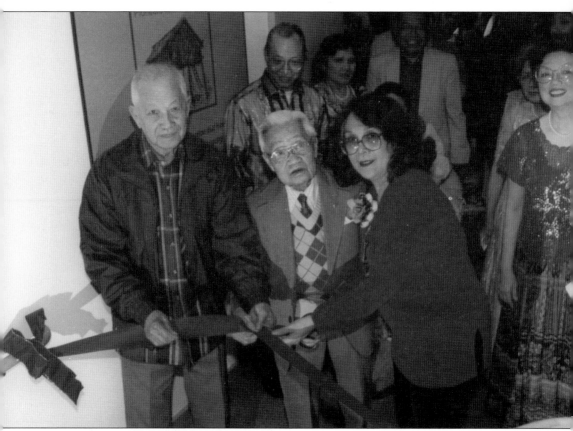

As Florence Gonzales (right) beams, Filipino American National Historical Society's executive director Dorothy Cordova assists the two oldest living Filipinos in Oregon—Marciano Pizarro, at left, and Manuel Mamaril Sr. They are cutting the ceremonial ribbon at the gala opening of the FANHS-OR exhibit *Filipino Americans: Pioneers to the Present* on June 4, 1997. The exhibit ran from June 1997 to February 1998 at the Oregon History Center in Portland. It was very well received by the greater community. Manuel Mamaril Sr. died two days short of his 100th birthday in 1999, and Marciano Pizarro was 105 when he died in 2008. (Courtesy FANHS-OR.)

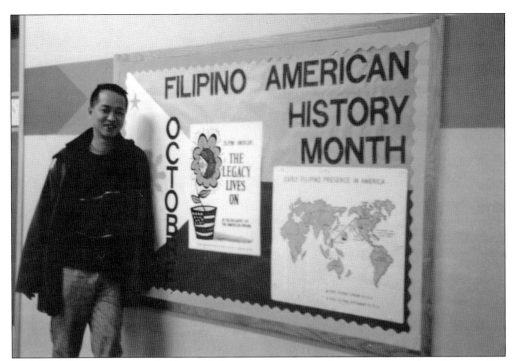

The first FANHS chapter to hold an exhibit in cooperation with a state entity was in Oregon. The exhibit was scheduled to close on December 31, 1997, but the Oregon Historical Society extended it to February 15, 1998. The poster on the wall was the cover of the exhibit souvenir program and was designed by artist Alberto "Joy" Asprec. (Courtesy Concordia Borja-Mamaril.)

Cording (right), as she is affectionately called, has an unheralded ally in everything she does for FANHS: her sister Teresa Borja Asprec, who stays with the Mamarils whenever she is in town. Teresa divides her time between Portland, the Philippines, and California, where her two sons, Joy and Mark, reside and work. (Courtesy Simeon D. Mamaril.)

FANHS did not have just old-timers. It also engaged the youth segment with meaningful activities, increasing their knowledge and appreciation of their Filipino American heritage. In the 1990s, the youth group was led by Claire Oliveros, a multicultural student coordinator at Portland Community College. In 2002, she headed a FANHS seminar workshop that featured Fred and Dorothy Cordova of the national office as speakers. (Courtesy Tyrone Lim and *MagNet*.)

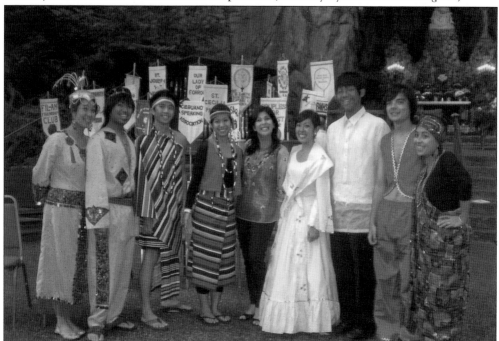

Joey Albert (center), a favorite and popular recording and concert artist, is a frequent visitor to Portland. This photograph was taken after her performance at the inauguration of the Filipino Shrine at the Grotto in Portland on September 28, 2008. (Courtesy Dolly Specht.)

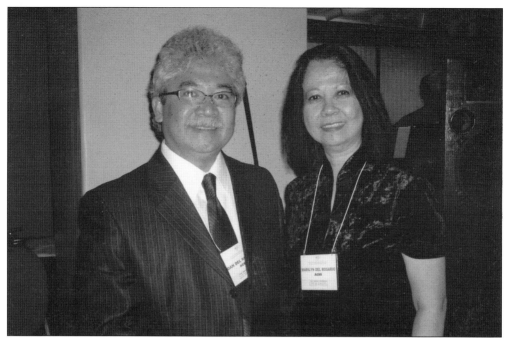

Like many other community leaders, Dan del Rosario (with wife Marilyn) has worn many hats in the service of the Filipinos in Oregon. He was the fifth president of the Oregon chapter in 2001, a co-organizer and president of the Aguman Capampangan regional group, and chaired the Council of Filipino American Associations from 2004 to 2005. (Courtesy Simeon D. Mamaril.)

There must have been a lively discussion, evidenced by the smile on Ligaya's face. In 2003 to 2004, Ligaya S. Humbert (center) was the FANHS-OR president. Prior to moving to Portland with husband Ken (right), she was president of the Greater Salem Filipino American Association from 1998 to 2000. (Courtesy Simeon D. Mamaril.)

Dory O. Lim held the reins of the FANHS-OR from 2005 to 2007. She worked in the medical profession on the East Coast before moving to Portland in the 1980s to be near her brothers Jess and Bob Osilla. She married Jaime Lim. In the photograph, Dory sits with Jaime, and behind them are Lourdes Markley (left, chapter president in 2008–2009) and FANHS executive director Dorothy Cordova. (Courtesy Simeon D. Mamaril.)

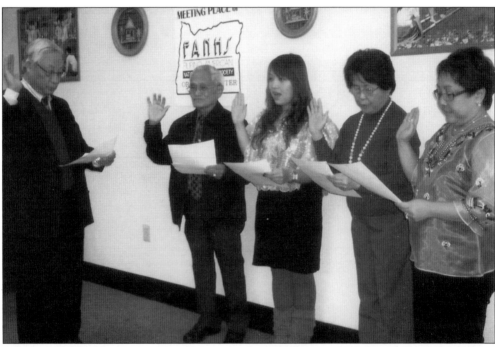

After Lourdes Markley's term, new officers were elected in January 2010. From left to right, Simeon Mamaril became treasurer, Consuelo Rivera secretary, Ruth Olandria vice president, and Dolly Pangan-Specht president. Ferdie Sacdalan conducted the swearing-in. In her message, Dolly revived the thrust to involve the youth. She wrote in the newsletter: "Remember just because we are a historical society doesn't mean we ARE history; more importantly we MAKE history!" (Courtesy Dolly Specht.)

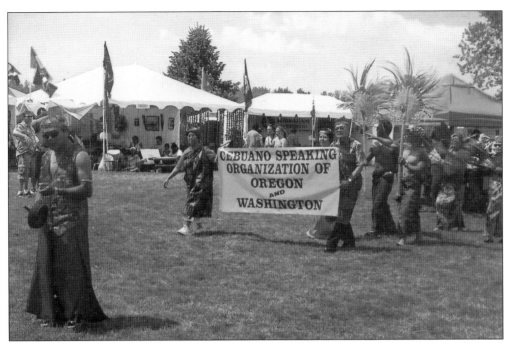

The Cebuano Speaking Organization (CSO) of Oregon and southwestern Washington paraded in the 2008 World Beat Festival in Salem. The Cebuano dialect is spoken in the central and southern Philippines, the second largest linguistic group behind the Tagalogs. CSO was born out of a desire to keep their dialect alive. It sponsors just two events every year: a summer picnic and a Christmas party. (Courtesy CSO and Ruth Olandria.)

The CSO was founded in 1988 by Willie Olandria (FANHS president in 1991–1992), who served as chairman until 1995. In the first years, donations were not enough to cover organizational expenses, so the group decided to impose a membership fee. At the 2008 Christmas gathering at Fowler School in Tigard are, from left to right, Ruth and Willie Olandria, immediate past president Julie MacFarlane 2007–2009, and Ben Laurente. (Courtesy CSO and Ruth Olandria.)

Marciana Liguid Hope (left) shows off one of her many awards, this one declaring her an Ambassador of Peace for the United World Federation in 2007. From first serving the Filipino American community as CSO chairperson in 1997–1999, Marci has held other leadership positions in the Council of Filipino American Associations (CFAA) and the Philippine American Chamber of Commerce (PACCO). A project most dear to her is the Little Children of the World–Ingan Leyte Project. (Courtesy Simeon D. Mamaril.)

Maricel Beaman and Danny Acantilado are among the stalwarts of the Cebuano Speaking Organization. Danny was chairman of the executive committee in 1997. Maricel is the current treasurer of the association in 2010; she hails from Davao, a city in Mindanao, the second largest island in the Philippines. Danny comes from Cebu City, the second largest metropolitan area in the country after Manila. (Courtesy Simeon D. Mamaril.)

A man with versatile talents, Rudy del Rosario opened a flower shop when he first arrived in Portland in 1984. Armed with experience in stage productions in the Philippines, he also conducted choirs and taught art classes, storytelling, and dramatization to young would-be artists. He later established the Teatro Bagong Silangan (Theater of the New East) in 1990. (Courtesy FANHS-OR.)

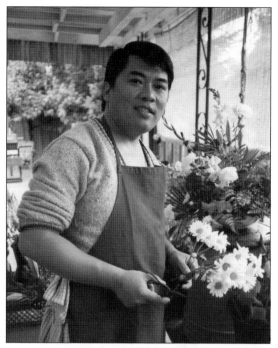

Salaam del Rosario plays princess in this *Singkil* Muslim dance from the southern Philippines in a photograph with Krystel (left) and Gennalyn Ganaban in 1998. When she was three years old, Sally asked, "Daddy, what is a Filipino?"—a simple question that jogged her father, Rudy, to put his artistic talents to use towards the perpetuation of the Filipino community's cultural heritage. (Courtesy Teatro Bagong Silangan and Tyrone Lim.)

Decisions at Teatro Bagong Silangan are made over home-cooked dinners, enjoyed at Rudy del Rosario's backyard garden. In 1998, preparations for the three-night Pagdiriwang (celebration) involved not only dances, but art and fashion exhibits, display of ethnic and native instruments, and food for sampling. (Courtesy Teatro Bagong Silangan and Simeon D. Mamaril.)

Without a permanent performance venue, Teatro Bagong Silangan did most of its preproduction activities at the home of founder Rudy del Rosario. This photograph shows a fun rehearsal including three of Teatro's onstage talents in 1998 and 1999. Standing from left to right are Francesca Fabile, Vanessa White, and Kathy Allegri. (Courtesy TBS and Tyrone Lim.)

In the year 2000, Teatro Bagong Silangan introduced a video production workshop to its young members. Here they do a location shooting at Rudy del Rosario's backyard, where participants learned the basics of filmmaking with the guidance of John Guy (with camcorder) from Tualatin Valley Cable Access. (Courtesy TBS and Tyrone Lim.)

The Portland Singing Christmas Tree is a longstanding holiday tradition that delivers the message of Christmas with a series of performances that begin right after Thanksgiving each year. In this 300-plus ensemble, the 11 Filipinos shown are, from left to right, (first row) Annie Maglalang, Dolores Ranum, Dolly Specht, and Cecille Agamata; (second row) Jo Cooley and Maria Aguila; (third row) Louisa Stevenson, Derick Maglalang, and Raquel Naval. Also pictured is ensemble member Jae Specht (far right) with an unidentified guest performer. (Courtesy Dolly Specht.)

Angie Turla kisses her husband, Ernie, on his 60th birthday. The nucleus of the Aguman Capampangan Northwest USA (ACNU) was formed in 1996 through Ernie's efforts; he was elected president of this group four times, serving from 2000 to 2008. The two presidents before him were Marita Villanueva and Dan del Rosario. (Courtesy Ernie and Angie Turla.)

Ernie and Angie were the pioneers of the Turla and Bonifacio clans in Oregon. The visa that they acquired for themselves in 1967 was the mother of all petitions that followed. This 1997 wedding of Angie's brother Brad to Shirley, in Florida, shows one of many reunions of the big Bonifacio clan. In the photograph, Angie is next to the bride and Ernie is behind her. (Courtesy Ernie and Angie Turla.)

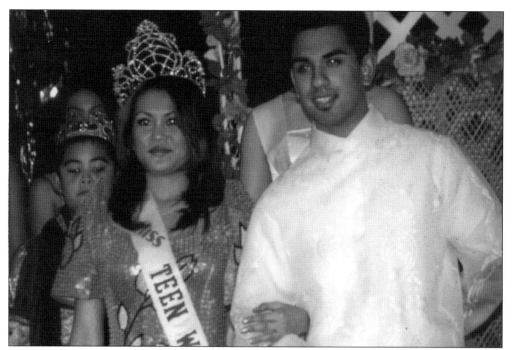

Miss Teen World Kayla Cumins is escorted around the ballroom by Allan Tahayeri at the 2002 Santacruzan, sponsored by the Aguman Capampangan. Celebrated in the month of May, the Santacruzan is a religious-historical pageant that depicts the finding of the Holy Cross by Queen Helena, mother of Constantine the Great. Many popular personalities (and beautiful ladies) are invited to enliven these events. (Courtesy ACNU.)

The Aguman Capampangan has always been eager to participate in gatherings by the Filipino community, even those hosted by other organizations, and they do it with pride carrying the name of their group. Taking a quick break from their picnic lunch, the following pose for a snapshot: (from left to right) Conrad Manuel, Beth Palomo, Lydia Lalic, and Isabel Cariño. (Courtesy Anthony Cassera.)

From the creative mind of its leader, Ernie Turla, came a unique way of gaining admission to the Aguman. Joining the club involved subjecting oneself to fun initiations. Applicants momentarily surrender their fate to the "masters" as a test of loyalty. Supplicants are blindfolded, led around perilous paths, and must pass a knowledge test of Capampangan lore before they are inducted as members. (Courtesy ACNU.)

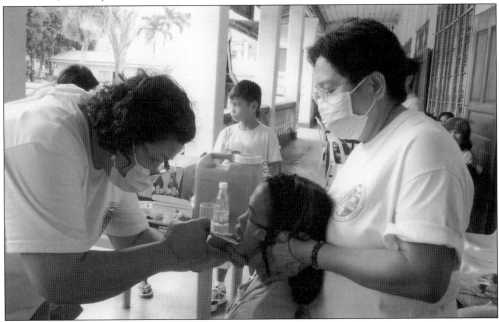

The Aguman gives back to their native region in the Philippines through a medical mission. Dr. Luz Tulipat (left) performs oral prophylaxis on a young patient as Mary Balino (right) assists. The Aguman offers its volunteer services to towns in Pampanga province but has expanded to provinces where participating Aguman members come from. (Courtesy ACNU.)

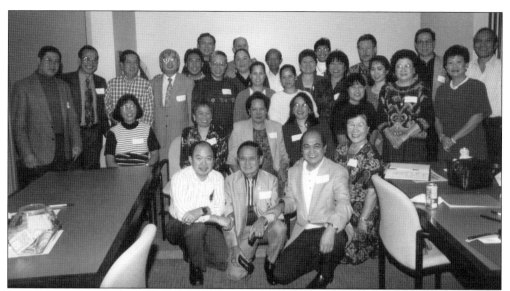

The Philippine American Chamber of Commerce of Oregon created a different buzz when it was formalized in October 1996. PACCO's establishment was featured in the *Filipino American Community News*, where the caption read in part: "Their interests in joining the Chamber were as diverse as the organizations they belong to, but one thing was sure, they were interested in making money and making lots of it." (Courtesy Simeon D. Mamaril.)

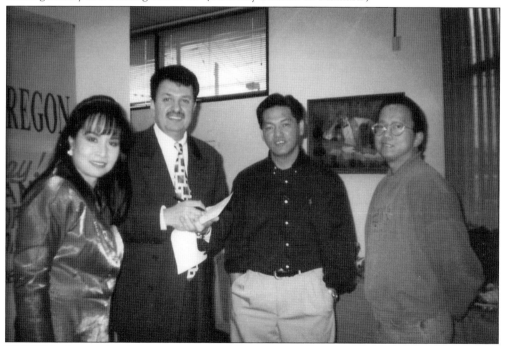

PACCO had engendered the entrepreneurial drive among Filipinos in the late 1990s. Chris Leung (second from right) and Raul Madarang (right) were among those who went into an import-export venture of high-tech component parts, while Mina and Akbar Tahayeri (left) have had their engineering services firm boosted in joining the chamber. Mina Tahayeri was elected ACNU's president in 2008 and again in 2010. (Courtesy Simeon D. Mamaril.)

Angie Collas-Dean meets with Pres. Fidel Ramos (clapping) in 1997 during the Philippine American Chamber of Commerce's (PACCO) first trade mission to the Philippines. While she was a member of the Oregon Commission on Asian Affairs, which was mandated to promote trading opportunities with Asian countries, Angie was elected as the PACCO's first president. PACCO strives to maintain valuable contacts with the Philippine government on trade issues affecting Oregon firms. (Courtesy Angie Collas-Dean.)

After her two-year term, Angie turned over the duties of PACCO president to Louis Lazatin in 1998. Louis is a mortgage banker and a staunch member of the Aguman Capampangan. He held the PACCO leadership position until 2002. (Courtesy Simeon D. Mamaril.)

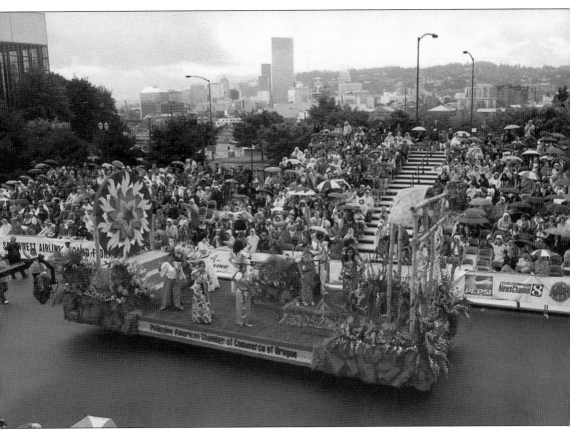

In the 1960s, the Filipino American Association entered floats in the annual Portland Rose Festival parade. That tradition of joining resumed again in 2003, 2004, and 2005, where this float received the Clayton Hannon Award for best self-built entries. With a break taken in 2006, the 2007 parade entry earned the Filipino American community the Golden Rose Award. Eliciting the cooperation of the other organizations in completing and engaging the float, volunteers worked around the clock pasting flowers and other decorations. PACCO also revived the Miss Philippines pageant, winners of which got to ride on the float. (Courtesy Simeon D. Mamaril.)

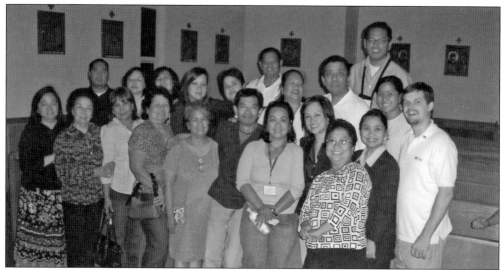

In 2006, a Brit named Dylan Wilk (far right) spoke to the Filipino community about his love for the Philippines, inspiring all those in attendance to advocate for Gawad-Kalinga (give care), a nation-building movement working to transform the poor in the Philippines. From this first seed, the first Oregon village in Camarines Sur province was born. (Courtesy Dolly Specht.)

In 2007, Pia de Leon (second from left) led a group of volunteers from Oregon and traveled to the Philippines to participate in the GKbuild of erecting homes for the poor. They rest here under the mural of the Oregon state map that they painted onto the wall of the International Village in Manila. From left to right are Pat Montone, Pia, Dolly Specht, and John, Joan, and Lindsey Winchester. (Courtesy Dolly Specht.)

The National Federation of Philippine American Chambers of Commerce conference, held in November 2008 in Las Vegas, was highlighted by the appearance of Filipino celebrities like world-champion boxer Manny Pacquiao, fresh from his victory over Miguel Cotto a few days earlier. PACCO president Jaime Lim, also the head of the national federation, stands behind Manny as he accepts the Global Entrepreneur of the Year 2009 award. (Courtesy Simeon D. Mamaril.)

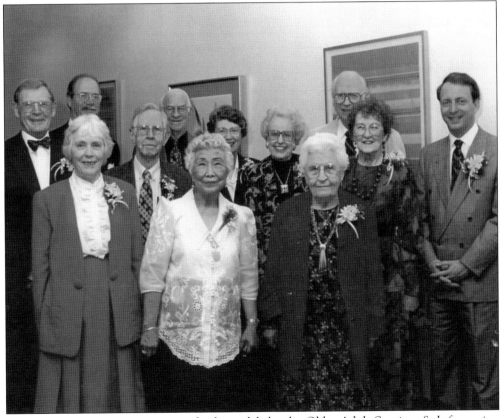

These senior volunteers were named role models by the Older Adult Services & Information System (OASIS), a national organization that aims to provide good quality life for seniors through the arts, humanities, volunteer services, and wellness programs. Narcisa Pimentel (front center) was one of the honorees in 1996. She was then president of Filipino American Portland and a member of the Multnomah County Commission on Aging. (Courtesy FANHS-OR.)

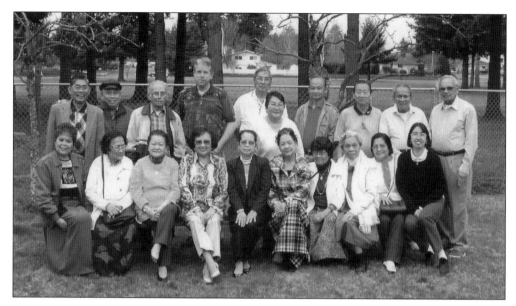

The Golden Agers, an organization of members 50 and older, was an offshoot of the Filipino Association of Clark County in Washington state. The most visible accomplishment of the association was the dedication of the historic Chumasero House in 1999. Alfred Chumasero, who moved to Vancouver in 1890 from Ohio, was believed to be of Filipino descent. He engaged in business, running a hardware store, then a pharmacy, even venturing in providing electricity to the city for three years until the business was bought by Portland General Electric. For his generosity, his obituary noted that his "philanthropy and kindness were done quietly and without ostentation." (Both, courtesy Simeon D. Mamaril.)

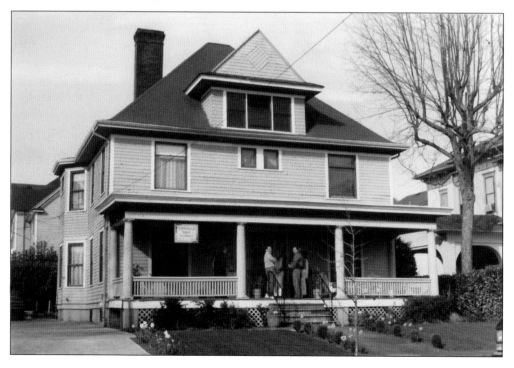

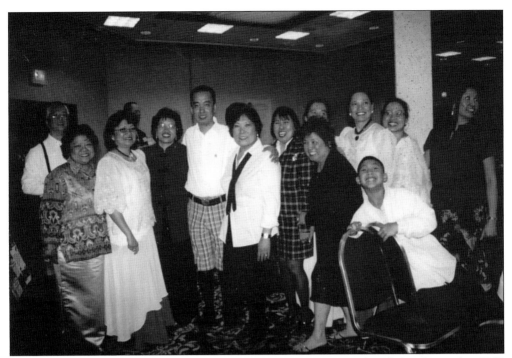

The Philippine Nurses Association of Oregon and Washington was founded in September 2002 by Fred Calixtro Jr. Its mission is to unite nurses in the region and provide outreach programs like blood pressure and glucose monitoring, immunization, and others for the community. They continue to grow as more and more nurses are hired in the local medical facilities and foster homecare becomes more popular. (Courtesy Simeon D. Mamaril.)

From left to right are Portland Seafarers Mission board president Jun Pioquinto, board member Corrie Lalangan, and executive director LeeLee Tan Castor at the 2002 Seafarers Festival in Vancouver. The mission is a nonprofit organization that provides services to seafarers who come into the area without partiality of race, religion, economic, or social condition. It is estimated that over 40 percent of the worldwide seafaring workforce is Filipino. (Courtesy Tyrone Lim and *MagNet*.)

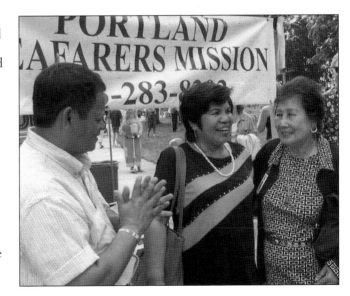

Monette Mallari (left) and Pia de Leon are just two of the tireless leaders of the Filipino Faith Community in the Willamette Valley. In 1997, they started what is to become the annual San Lorenzo Ruiz Celebration every September. St. Lorenzo Ruiz is the first Filipino saint, canonized by Pope John Paul II in 1987. (Courtesy Simeon D. Mamaril.)

Catholic Filipinos would celebrate all holy days of obligation and saints feast days if they could. Another big annual event is the Santo Niño Celebration held at Mt. Angel Seminary in January each year. In January 2010, Bishop Oscar Solis, the first Filipino bishop ordained in the United States, was the main celebrant of the mass. Here he stands center among the Filipino seminarians at the abbey. (Courtesy Dolly Specht.)

Fr. Ricky Manalo speaks at a Lenten forum in 2002 at the St. Pius X Catholic Church in Portland, organized through the social justice ministry of the church and coordinated by Pia de Leon. Father Ricky is also a composer by vocation, and his songs are published and sung at Catholic masses in the United States. (Tyrone Lim and *MagNet*.)

Fr. Denish Ilogon smiles as Fr. Henry Rufo solemnly processes in for the Santo Niño Celebration in January 2010. After serving at the Grotto, Father Ilogon returned to the Servites in the Philippines. Fr. Henry Rufo is the first Filipino priest of the Portland Archdiocese, after being ordained in 2001. (Courtesy Dolly Specht.)

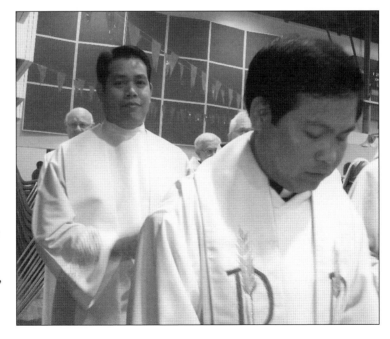

Just like in the Philippines, the majority of Filipino Americans in metro Portland are Roman Catholics. There are some who belong to other denominations like the Baptists. Pastor Agapito Bernardo was the first minister of the American Filipino Baptist Church in Portland. (Courtesy FANHS-OR.)

The Dambana at the Grotto in Portland is an impressive showcase of Filipino culture, art, faith, and the camaraderie of the entire Filipino American community. The glass enclosure protects statues created by Ferdie Sacdalan, namely our Lady of Dambana, Santo Niño, and San Lorenzo Ruiz. This gazebo-like structure, designed like a native Filipino hat, is a must-visit for every Filipino who comes to Oregon. This is our legacy. (Courtesy Dolly Specht.)

Six

AIMING FOR UNITY

Over 10 years ago, heads of several Filipino American organizations started meeting and immediately got the overall feeling that, although there are many organizations, they are one community. Such a community coming together is the story of CFAA, the Council of Filipino American Associations, broad enough to encompass the state of Oregon and southwestern Washington. Thus, there are affiliate associations outside the Willamette Valley, but we consider them part of the community.

What started in 1996 as an attempt to create a professorial endowment at the University of Oregon in the name of former Philippine president Corazon Aquino, snowballed into a community council, a coordinating body of community leaders, with the individual associations on board as affiliated organizations. The affiliates are fully autonomous, but CFAA encourages full cooperation and facilitates collaboration, allowing for pooling of resources and always on the lookout for opportunities that benefit the entire community.

The seeds of the council were sown over the years, starting in 1978, with the many cooperative endeavors of the Filipino American groups existing in the region. One such activity was the massive assistance effort for victims of the Mt. Pinatubo volcanic eruption in 1991. Another was the Philippine Independence Day celebration every June 12 at the capitol grounds in Salem. Then there was the annual Asian Festival in Portland's Pioneer Courthouse Square, of which the Filipino community was an active participant. Each of these endeavors needed to solicit the support of the many Filipino American associations. The coming of the community council was inevitable.

As the Filipino American population increases, CFAA's challenges are greater, but so are the opportunities. In the words of past chair Eric Tadeo, "ultimately, its success lies in the underlying attitude that CFAA exists to serve the community, not to be served by it."

Gil Alviar (at left) of the Filipino American Friendship Club and Jaime Lim (below) of Filipino American Portland were presidents of their respective organizations in 1978 when they planted the seeds of an advisory and coordinating council envisioned to unite the various organizations under one umbrella. By the 1990s, the seed had taken root and sprouted, and a new living organization was striving to grow. (Both, courtesy FANHS-OR.)

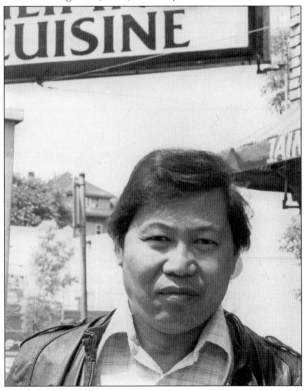

Philippine president Corazon Aquino was the commencement speaker at the University of Oregon graduation ceremonies in 1995. She met with Filipino community members at a reception afterwards. In 1997, she was invited back to UO and was conferred an honorary doctorate degree in recognition of her efforts on global reconciliation and peace. (Both, courtesy Tyrone Lim.)

Leaders in the Filipino community dubbed "presidential group" listen to a proposal from the University of Oregon to create a professorial chair in the name of Corazon Aquino. At the dining table are, from left to right, Angie Collas-Dean; Concordia Borja-Mamaril; Bennie Ramirez, FAFC; David Begun, UO director of development planning; Susan Plass, vice-provost for international affairs; and Cynthia Mounts. Standing in back is Frank Irlandez. (Courtesy Medy Saqueton.)

Ronnie Lim was the energy behind the organization of the Filipino Community Council. He set up the organizational meeting of Filipino leaders in May 1998, drafted the initial bylaws, and facilitated the first general convention in December 1999 in Salem, culminating in the incorporation of the successor organization CFAA. (Courtesy Simeon D. Mamaril.)

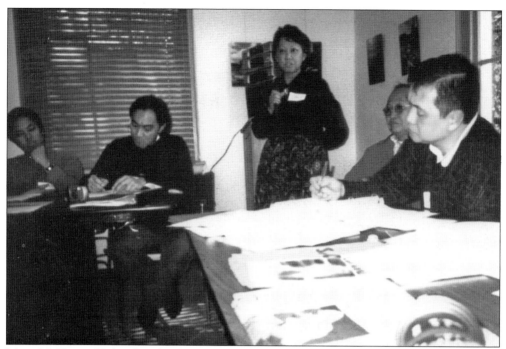

Marie McHone of Salem has the floor in this Council of Filipino American Associations (CFAA) board meeting in March 2001 in Roseburg. Quarterly board meetings are rotated among affiliates, an arrangement that invites closer cooperation among organizations around the state that would otherwise be separated by distance. In the photograph are, from left to right, Manny Santiago, Teatro Bagong Silangan; Alex Balais, Oregon Coast Filipino American Association; Marie; Frank Irlandez, chair; and Ronnie Lim, secretary. (Courtesy Tyrone Lim and *MagNet*.)

The CFAA held its 2005 convention at the Seven Feathers Casino Hotel in Canyonville, Oregon. Delegates included, from left to right, Dorothy Caliva, board member of the host affiliate Douglas County Filipino American Association; Cynthia Mounts, DCFAA founding president; Kitty Miller, founding board member; and Fely Hendrix, president. The convention conducted different workshops for the participants. (Courtesy Cynthia Mounts.)

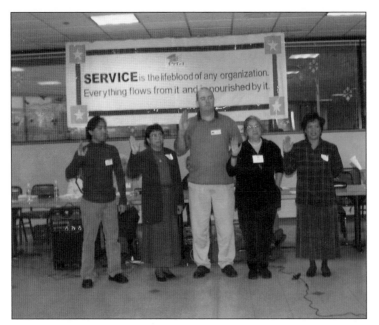

Frank Irlandez was the first chairman of the Council of Filipino American Associations when it incorporated in 2000. He was also interim chair from May 1998 when the council was created. He inducted the 2002–2003 batch of officers, from left to right, Alex Balais, assistant secretary; Mary Balino, assistant treasurer; Paul Hale, vice chair; Angie Collas-Dean, secretary; and Cynthia Mounts, chair. (Courtesy Tyrone Lim and *MagNet*.)

Under Gov. John Kitzhaber (right), the Oregon Commission on Asian Affairs (OCAA) was established in 1995 to facilitate trade with Asia. Later the mandate shifted emphasis on advocacy for the Asian communities. Cynthia Mounts (left) of Roseburg became chairperson in 2000 when she announced the holding of a summer Asian festival every May, which is Asian-Pacific Heritage Month. (Courtesy Simeon D. Mamaril.)

Dolly Specht (left) tries to carry the 2009 International Boxing Association's super bantamweight belt with the help of rightful owner Anna "the Hurricane" Julaton (center). Together with Nanette Alcaro (right), president of FilipinoVillage.com, these ladies were among the Top 100 Most Influential Filipina Women in the U.S. This prestigious award was given on this gala night of the Filipina Women's Network Summit held in Berkeley, California, in October 2009. (Courtesy Nanette Alcaro.)

Ephraim Roxas, CFAA chairman for 2010–2011, handsomely poses with beautiful wife Norma. In 2002, Eping once quipped, "I think the major thing that the Filipino community does is create organizations and then disband, then create another and then disband." This book, however, proves that whether disbanded or united, the Filipino community is a force to be reckoned with in the Willamette Valley. (Courtesy Ephraim Roxas.)

www.arcadiapublishing.com

Discover books about the town where you grew up, the cities where your friends and families live, the town where your parents met, or even that retirement spot you've been dreaming about. Our Web site provides history lovers with exclusive deals, advanced notification about new titles, e-mail alerts of author events, and much more.

Find Your Place in History.